IMAGES
of America

GENEVA

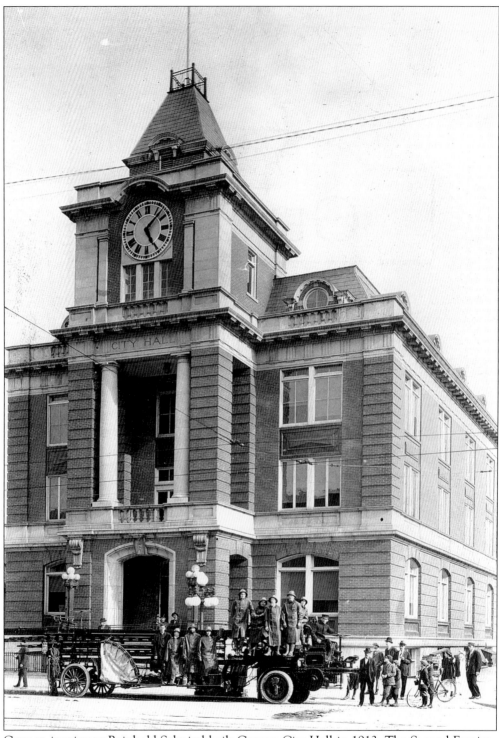

German immigrant Reinhold Schnirel built Geneva City Hall in 1913. The Second Empire–style building has had little alteration and appears the same today as when it was built. The fire apparatus in the foreground is Geneva's first motorized fire engine.

IMAGES
of America

GENEVA

Geneva Historical Society

ARCADIA

Published by Arcadia Publishing
Charleston SC, Chicago IL, Portsmouth NH, San Francisco CA

Printed in Great Britain

Library of Congress Catalog Card Number: 2003102247

For all general information contact Arcadia Publishing at:
Telephone 843-853-2070
Fax 843-853-0044
E-mail sales@arcadiapublishing.com
For customer service and orders:
Toll-Free 1-888-313-2665

Visit us on the internet at http://www.arcadiapublishing.com

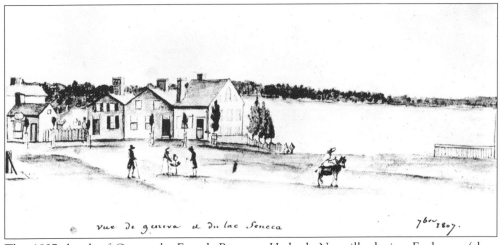

This 1807 sketch of Geneva by French Baroness Hyde de Newville depicts Exchange (then Water) Street and Seneca Lake beyond. The incline from the street to the lake is apparent.

CONTENTS

ACKNOWLEDGMENTS

Heather Hawkins, William Smith College '03, began this project as our museum intern, reviewing our entire image collection and selecting appropriate shots for the book. She also conducted preliminary research and arranged the chapters. Shana Hawrylchak, William Smith College '03, volunteered time to research and check facts and to prepare the final chapters. Although most of the images in this book are from the Geneva Historical Society's permanent collection, we are indebted to people who lent us photographs: Robert and Ronald Anania; De Sales High School; Sara Greenleaf and Clayton Adams at Warren Hunting Smith Library, Hobart and William Smith Colleges; and Mr. and Mrs. Robert Lautenslager.

Although the historical society has much information in its archives, it is not the source of all Geneva knowledge. We at the society thank the many individuals around town who helped us with names, dates, and street addresses. Linda Benedict and other staff at Warren Hunting Smith Library were particularly helpful with Hobart and William Smith Colleges facts. We also relied on published local histories by the Reverend James Adams, G. David Brumberg, E.T. Emmons, Dan Ewing, Paul and Ellen Grebinger, Kathryn Grover, Carol Sisler, Warren H. Smith, and Michael Wajda. Nancy Bauder, Heather Marks, Karen Osburn, and Bette Schubert all assisted with proofreading—we hope nothing has slipped by us.

Finally, we thank all the people who have donated images to the permanent collection. For every image we have, there are 10 more we wish we had. If you would like to learn more about our collection or have photographs to donate, we will be happy to talk with you.

—John C. Marks
Curator of Collections

INTRODUCTION

Photography has allowed us to capture the moment. It seems that photographs, especially old photographs, are enjoyed by nearly everyone. They are virtual time machines, taking one back to days gone by, reminding us of past people, places, and things. I am sure that you have heard the expression "a picture is worth a thousand words." Well, it is true. People look at or study photographs for different reasons, depending on their interest or curiosity. One person will be drawn to one part of an image while another person will notice something different. Old photographs may illustrate changes in a community, differences in lifestyles, changing modes of transportation, improvements in technology, or a vanished landscape. At the same time, photographs serve as reminders of friends and loved ones, social gatherings, celebrations, and, unfortunately, fires and other types of catastrophes.

Professional photographers appeared in Geneva in the later part of the 19th century, as they did elsewhere in the country. Over the years, Geneva has had its share of professional and amateur photographers. As a result, the Geneva Historical Society has been fortunate to amass a collection of more than 15,000 images dating from the 1850s to present, and we receive more every day. This extensive collection made the compilation of this book difficult. Choices had to be made by our curator, John Marks, and his assistant Heather Hawkins. The result is that the 218 images shown here cover only the period of Geneva's history from 1840 to1940.

This book is not intended to be a comprehensive history of Geneva. It is, rather, a selection of rarely seen images with a brief text. Our objective is to offer an enjoyable visual experience and, at the same time, leave the reader with an understanding of Geneva's beginnings and development.

It is appropriate in this introduction to provide the reader with a "sense of place." Although it cannot be documented, it is thought that Geneva was named after Geneva, Switzerland. The city is located at the north end of Seneca Lake, in the Finger Lakes Region of New York State, and midway between Rochester and Syracuse.

This area was home to the Seneca Indian Tribe, a member of the Iroquois Confederation. In the 18th century, the Senecas, along with the other nations of the confederation, sided with the British, first against the French, and then against the American revolutionaries. In the 1750s, the British built a fortification known as Kanadesaga, or "new settlement." During the Revolution, Loyalist units, aided by their Iroquois friends, used Kanadesaga as an encampment area to conduct raids on Pennsylvania and the New York frontier. In 1779, George Washington ordered Gen. John Sullivan to rid the area of the Indian problem. With 5,000 men, he drove the Native Americans north, burning their villages and crops. The Sullivan campaign basically left Geneva open for white settlement. Many of Sullivan's men, finding fertile land yielding all kinds of fruits and vegetables, settled here after the Revolution.

The formation of the city as we know it today began in 1792, when the Pulteney Associates hired Charles Williamson as its land agent. Williamson set out to develop the city and promote the Genesee Country. Williamson promoted the fertility of the land, "the County of Ontario shows every sign of respectability; no man has put the plough in the ground without being amply repaid." The region was promoted to the farmers of New England, where the soil was rocky and hard, and to the farmers of Maryland and Virginia, where the once

fertile soil was exhausted. With the opening of the east–west turnpike from Albany and the Cumberland Pike, settlers came from New England, eastern New York, Pennsylvania, Maryland, and Virginia. Williamson's efforts were fruitful. The population of the Genesee Country in 1791 was about 1,000; by 1795, about 12,000; and by 1810, about 30,000. Geneva had reached such an advanced level of development that it was referred to as "an oasis of civilization in this wilderness."

Geneva was incorporated as a village in 1806 and as a city in 1897. It developed into a major industrial and commercial center by the beginning of the 20th century, as the city's population had grown to over 15,000. Geneva was no exception to the suffering of the Great Depression. The greatest growth period was in the 1940s, when two military facilities were built nearby: Sampson Naval Training Center and the Seneca Army Depot. Population in the city jumped to over 20,000. The 1950s and 1960s witnessed the industrial migration to the West and South, and the city's population began a downward spiral. Today, there are 13,000 people living in the city, and in the past 10 years, new industry has come to town and the area is becoming a major tourist destination.

The Geneva Historical Society has been collecting and preserving Geneva's heritage since 1883. The society operates a museum and three historic properties, including the 1839 Greek Revival Mansion at Rose Hill—a National Historic Landmark.

I trust that you will enjoy this book and that Geneva's images will foster treasured memories of times past.

—Charles C.W. Bauder
Executive Director, Geneva Historical Society
June 2003

One

THE HILL AND
THE BOTTOM

Henry Maude visited Geneva in 1800 and described it in this way: "Geneva is situated on the north-west extremity of Seneca Lake. It is divided into Upper and Lower Town. The first establishments were on the margin of the lake as best adapted to business; Captain Williamson, struck with the peculiar beauty of the elevated plane which crowns the high bank of the lake, and the many advantages which it possessed as a site for a town, began here to lay out his building lots parallel with and facing the lake." To this day Geneva has been divided into the Hill and the Bottom—the quiet, cultured, and picturesque Upper Town and the noisy, commercial, and sometimes unsightly Lower Town.

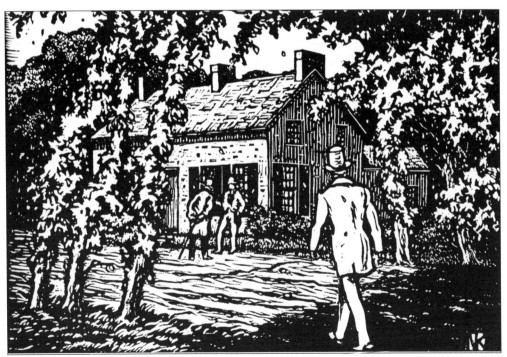

Sir William Pulteney, William Hornby, and Patrick Colquhoun (the Pulteney Associates) bought the Geneva land from Robert Morris (financier of the American Revolution) in 1792 for 75,000 pounds. The Genesee Country ran from Seneca Lake to the Genesee River and from Pennsylvania to Lake Ontario—1.27 million acres. This woodcut by Norman Kent (1903–1972) illustrates a typical day at the land office, which was located on Washington Street.

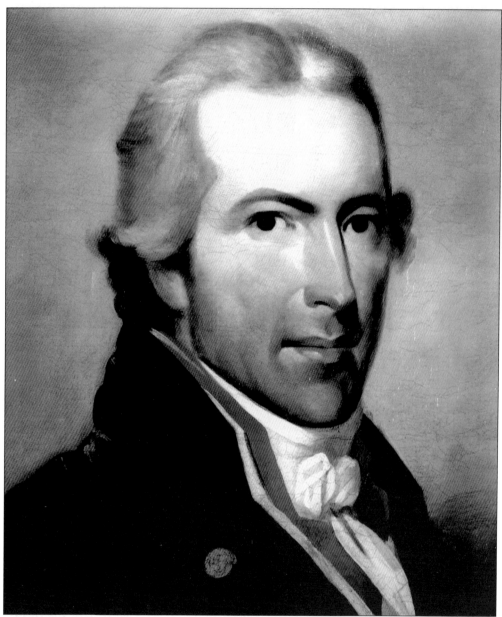

Capt. Charles Williamson (1757–1808) was born in Scotland and became a naturalized U.S. citizen. Sir William Pulteney's land agent, Williamson is considered the "founder" of Geneva. He signed the deed for the British investors, as foreigners were not allowed to own land in New York at the time. His vision for Geneva was a commercial district around Pulteney Park, located on the Hill, which afforded the best view of the lake and was above the marshy area that is today's downtown. By 1800, the Pulteney Associates had invested more than $1.3 million to develop the Genesee Country. The return on this investment was only $147,000, and Williamson was relieved of his duties. By this time, promoter Williamson had attracted settlers from New England, Pennsylvania, eastern New York, Maryland, and Virginia. He made his mark, and in his wake, he named many streets and places, including the Steuben County town of Bath (named after Sir William Pulteney's daughter, the Countess of Bath).

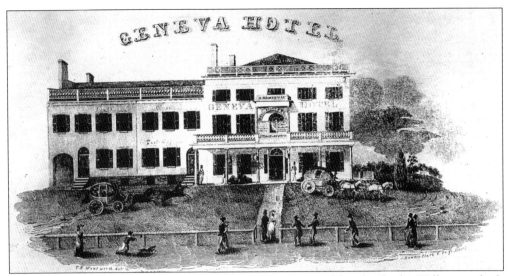

An essential factor in attracting people to Geneva was a good hotel. Charles Williamson built the Geneva Hotel on Pulteney Park in 1796 at a cost of $15,000. Diaries and letters of visitors claim it to be the finest hotel in this part of the state. Thomas Powell, a British innkeeper, was the hotel's first proprietor. This drawing by artist T.H. Wentworth reflects a great deal of activity around the hotel.

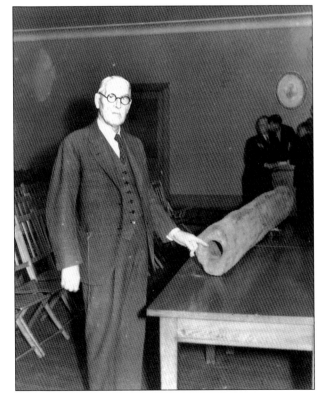

A municipal water supply was fairly rare when the Geneva Waterworks Company was formed in 1796. Here, former city historian George Hawley is seen with one of the original wooden pipes that brought water from the White Springs, a distance of 1.5 miles, to pumps outside Geneva homes. The wooden pipes were replaced with iron pipe c. 1846.

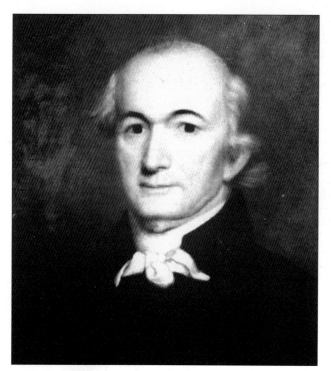

Robert Rose (1774–1835) was part of the Virginia immigration to Geneva. The Rose and Nicholas families—17 individuals and 75 African Americans—moved to this area in 1803 from Stafford County, Virginia, in search of new fertile farmland. Robert Rose settled east of Geneva at Rose Hill, while John Nicholas, Rose's brother-in-law, settled at White Springs, west of Geneva. Their slaves became the foundation for Geneva's African American community.

Geneva's first homes were built on the Hill on South Main Street overlooking the lake. A variety of architectural styles is evident, and the street is listed on the National Register. The southern influence is evidenced by the columned house on the left. In the early 1900s, elms formed a canopy over the street. In the 1960s, the trees fell with the spread of Dutch elm disease.

This late-19th-century image is a view of Pulteney Park, looking south across the park. On the right is the Geneva Water Cure (formerly the Geneva Hotel). In the early part of the century, Geneva's commercial district surrounded the park, and the park served as a "municipal" parking lot for stagecoaches.

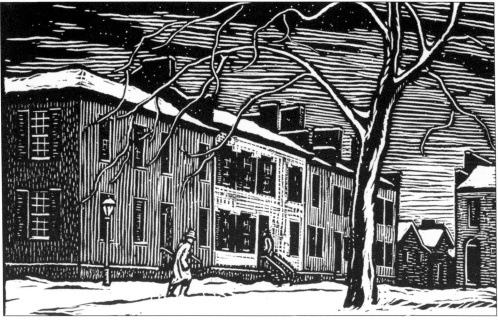

This is artist Norman Kent's depiction of a snowy day at Pulteney Park. The south side of the park was known as Bank Alley. Located there from 1821 to 1831 was the Bank of Geneva, the next building in from the corner in the heart of town. Businesses were on the ground floor of the row houses, with living quarters above. The commercial district eventually moved from the Hill to the Bottom.

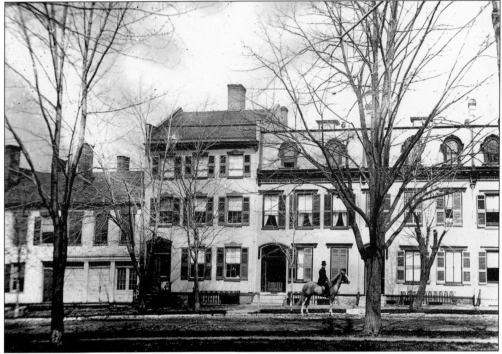

Joseph Annin's 1793 survey of Geneva established the village's center overlooking Seneca Lake. The distinctive row houses reflect an architectural style found only in larger cities. This 1870s view shows the buildings as residences. Charles Williamson's original plan called for the street's east side to remain undeveloped to the lakeshore. Real estate pressures being the same then as they are today, houses began appearing on the east side after 1800.

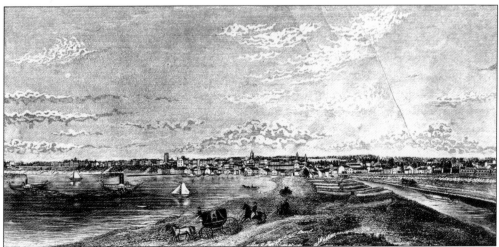

This lithograph was made from an original sketch drawn *c.* 1836 by regional artist Henry Walton. Allowing for artistic license, it shows Geneva as a bustling community with several church steeples and waterfront development. The most significant detail is the Seneca-Cayuga Canal, which was dug at the end of the lake to avoid rough water. It connected Seneca Lake—and Geneva's fortunes—to the Erie Canal.

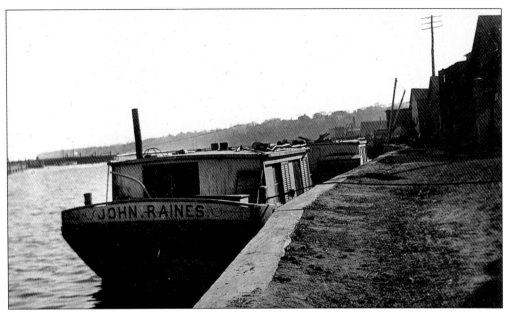

Regular lake traffic began in 1796. In 1813, the Seneca Lake Navigation Company was formed to develop the Seneca-Cayuga Canal, a means of connecting Geneva with a water route to Utica and Albany. In 1825, this canal was connected to the Erie. This 1896 Vail photograph shows the entrance to the canal basin.

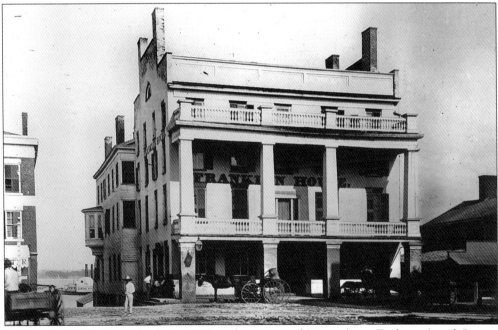

The Franklin Hotel was built in 1825 at the corner of Water (now Exchange) and Seneca Streets. The Erie Canal opened that year, and business interests moved to be near the lakefront and transportation routes. General Lafayette greeted Genevans in Pulteney Park and lunched at the new Franklin Hotel in 1825. The Franklin supplanted the Geneva Hotel as the main hotel and marked the business shift from the Hill to the Bottom.

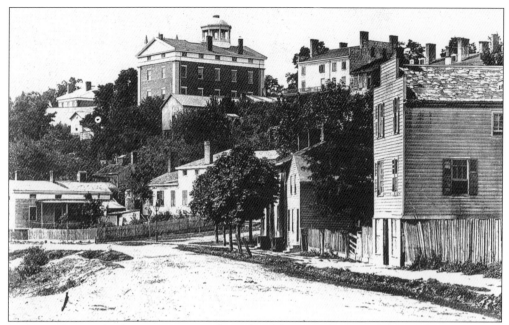

Exchange Street, the Bottom, was an industrial and business district, while South Main Street, the Hill, was home to higher learning and higher-income housing. This southwest view from South Exchange Street features the Geneva Medical College on the hill, built in 1841. The photograph was taken before November 1877, when the Medical College burned. The loss of the building and its contents amounted to $100,000.

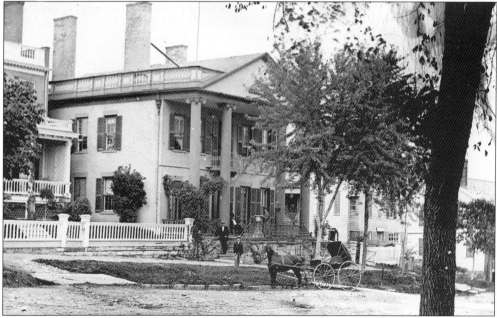

This Federal-style building, located on Main Street at the head of Seneca Street, is commonly known as the Geneva Women's Club, but from 1831 to 1862, it was home to the Bank of Geneva. The bank was established at 528 South Main Street in 1817. It became Geneva National Bank in 1865 and settled on the name of the National Bank of Geneva in 1923.

16

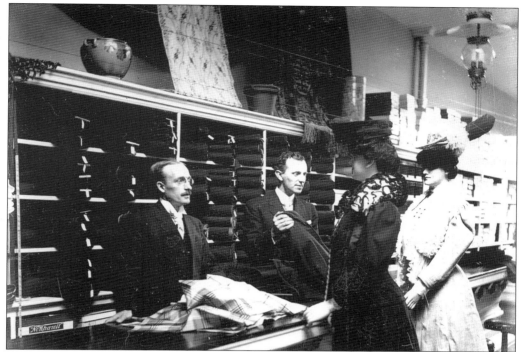

J.W. Smith Dry Goods was in business at 40–42 Seneca Street from 1847 to 1977. "Dry goods" means clothing, textiles, and related goods. This early-20-century interior view shows William H. Stewart and Edward E. Ludlow in front of bolts of dress goods, waiting on two mannequins. Eventually, the store increased its offerings and floor space. When it closed, it was one of the country's oldest continuously operating department stores.

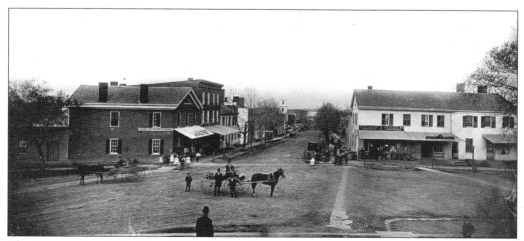

The intersection of Castle and Main Streets boasted two grocery stores when this photograph was taken c. 1875: Gasper & Ottley and Pembroke Brothers. Castle Street was the path from Seneca Lake to the Seneca Indian settlement, or Castle, as the Europeans named it. This photograph shows a mix of wooden and brick structures. By the late 19th century, the majority of buildings were of brick.

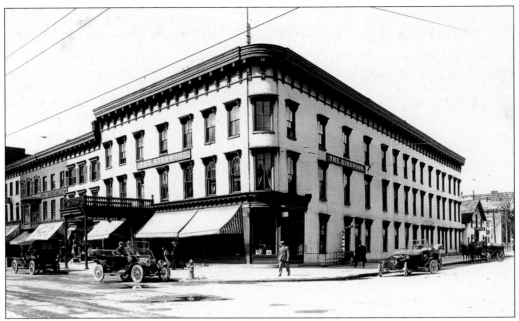

This hotel, built c. 1858 at the corner of Exchange and Castle Streets, was known as the Temperance House, the Vezie House, the American Hotel, and in the 20th century, the Kirkwood. This photograph was taken c. 1910. Note the 1906 post office at the far right. The Kirkwood was torn down in the 1960s to make way for the new Geneva Federal Savings and Loan building.

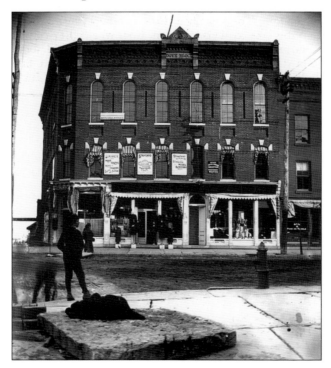

The Dove Block was built by W.G. Dove & Son after an 1876 fire destroyed three buildings at the corner of Castle and Exchange Streets. The third floor, Dove Hall, was used for public events. In 1936–1938, artist Arthur Dove and his wife, Helen Torr, also an artist, lived on the third floor. There, he painted some of his largest and most notable canvases. The building's appearance has changed little since this photograph was taken c. 1877.

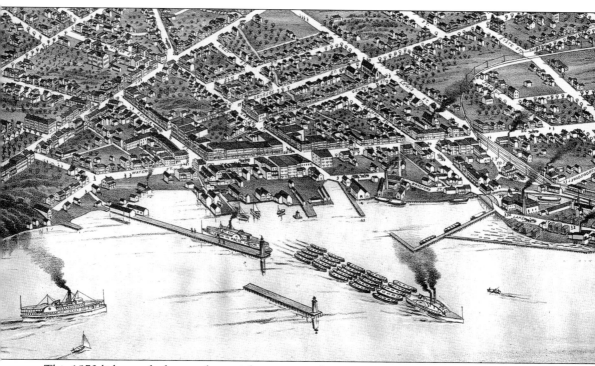

This 1873 lithograph shows substantial progress in the community since Henry Walton's sketch of the village in 1836. Steamboat piers created a safe harbor from Seneca Lake's damaging waves, but the New York Central Railroad (upper right) signaled the end of lake transportation. Notice the buildup of industry on the lakefront. The steamboat (lower center) illustrates the method used for towing canal barges up the lake to Watkins Glen, from where they carried goods to the Chesapeake Bay. From Geneva, agricultural products and manufactured goods could be shipped to markets anywhere in the world: north, east, and west by way of the Erie Canal to either the Great Lakes or Hudson River; and south by way of the Chemung Canal, the Chemung River, and the Susquehanna River.

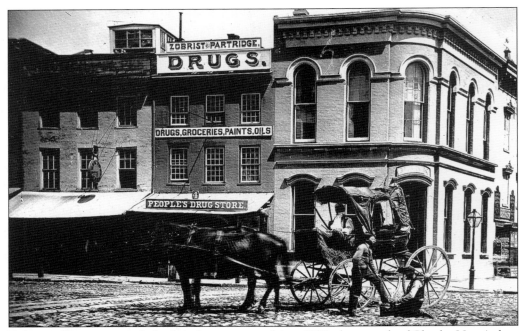

Either traffic was particularly slow downtown or this c. 1880 photograph of Charles Van Auken having his boots blacked was staged. People's Drugstore does not appear in the directories, but Zobrist and Partridge shared space around this time. In 1862, the Geneva National Bank moved to the corner of Seneca and Exchange Streets, and c. 1900, the bank expanded its building into the drugstore space.

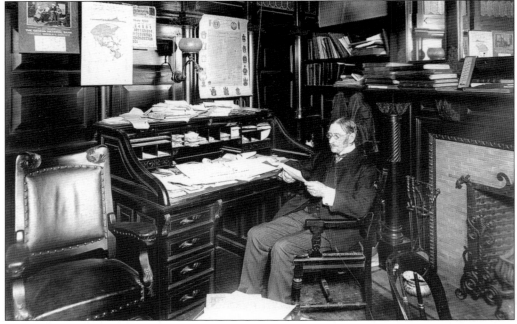

This 1905 photograph shows the banking office of Samuel H. VerPlanck (1860–1907), president of the Geneva National Bank. My, how offices have changed in 100 years.

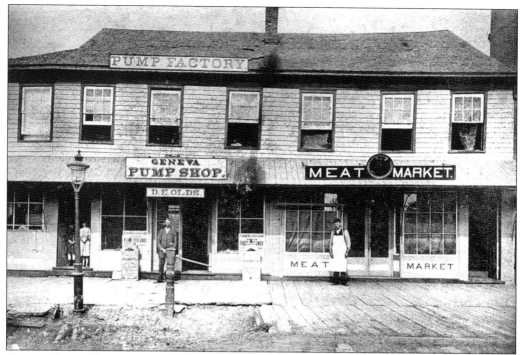

Geneva Pump Shop was run by Dana E. Olds, pump manufacturer, at 110 Exchange Street (on the west side, just south of Tillman Street). The meat market, at 108 Exchange Street, was owned by James W. Ryan. This photograph was probably taken *c.* 1884, the one time that these businesses overlap in city directories. Prior to World War II, Geneva's downtown was the principal shopping center for the surrounding area.

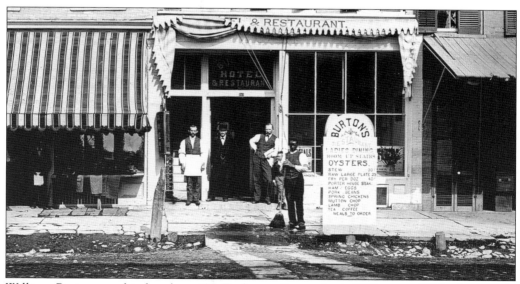

William Burton ran his hotel at 496 Exchange Street from 1879 to *c.* 1895. Apparently oysters were a popular item at 19th-century hotels and cafés. At this time Geneva had a small community of African Americans, who worked in service positions.

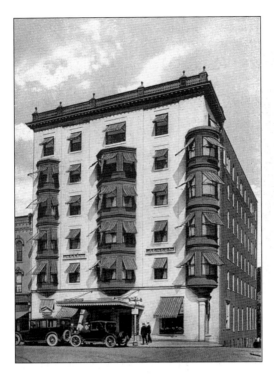

Brewer Samuel K. Nester opened this hotel in 1897 as the Nester. This c. 1915 photograph notes the name change to the Seneca and shows the 1913 expansion and addition of a sixth story. There were 19 hotels in Geneva in 1913, and this was the grandest. The bar was a favorite "watering hole" for Hobart College students. The hotel was demolished in 1982 to make room for an apartment complex for senior citizens.

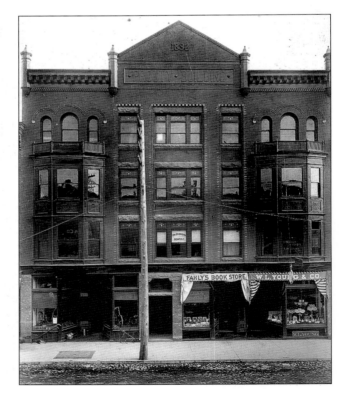

The site of the Prouty family hardware business, this building went up well before 1892, the year the structure was altered and the pediment added. The building survived a 1925 fire, but the pediment did not. The building hosted many small businesses. From the 1920s through the 1960s, Neisner Brothers Five Cent to a Dollar Store was a major tenant. Today, the building appears essentially the same.

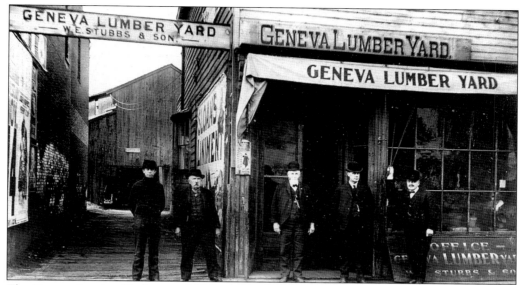

The Geneva Lumber Yard was at 372 Exchange Street from c. 1892 to 1925, when it moved to Lewis Street. After the move the business was called Stubbs Lumber Company. Watson E. Stubbs and Son were the owners; the management is probably represented by the three men in bowler hats on the right. The site remained a lumberyard throughout most of the 20th century.

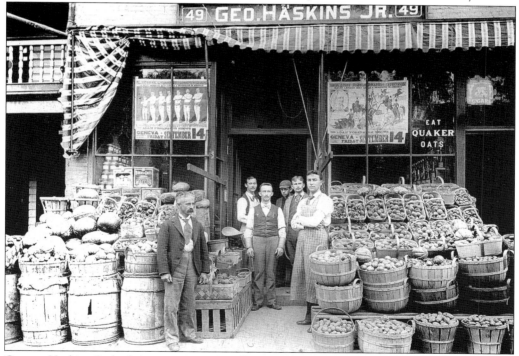

George Haskins Jr. had a grocery store on Seneca Street for about 11 years; this photograph was taken c. 1892, when Haskins was at 49 Seneca Street. There were more than 30 grocers in Geneva in the mid-1890s. Much has changed since then, but grocers still need to have a flair for displaying vegetables.

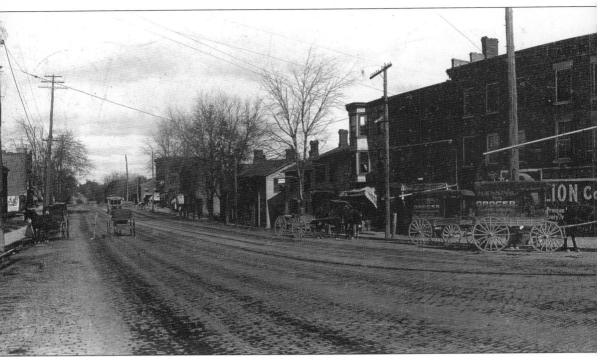

This panorama of the corner of Seneca and Main Streets was probably taken *c.* 1901. The right-hand view is looking east toward the Nester Hotel and the lake. Haskins Grocery has moved to the corner. Part way down the block is a two-story building, the Folger Hook & Ladder

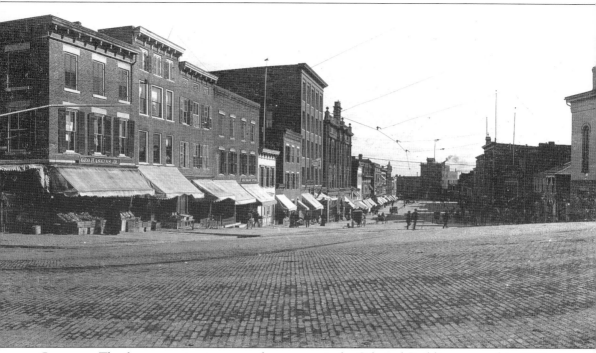

Company. The five-story structure, two doors away, is the Schnirel Building, erected in 1899, the first building in Geneva to have an all-steel frame. Up Main Street, in the left-hand view, there is less commercial activity in the block between Seneca and Castle Streets.

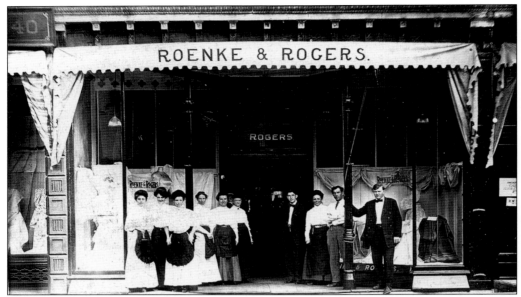

Roenke & Rogers Dry Goods began business in 1881 in Penn Yan. The partnership opened a store in Geneva in 1889 next door to J.W. Smith Dry Goods. The store became J.R. Roenke in 1922, when the partners separated. After competing for 35 years, the businesses merged in 1929. In 1930, brothers Henry and Richard Roenke acquired controlling interest in the combined business. This early-20th-century photograph shows Richard Roenke in the doorway.

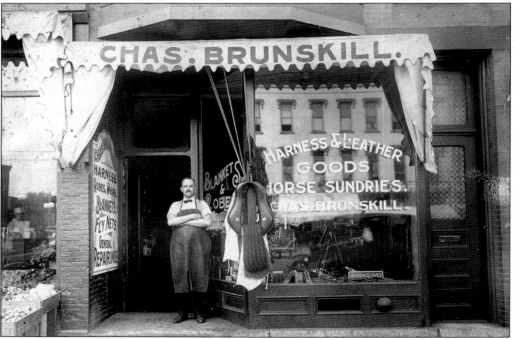

Charles Brunskill opened his harness-making shop c. 1897 at 438 Exchange Street. He coped with the advent of automobiles by selling leather goods as well. The business survived Brunskill's death c. 1941 and remained at the same location until the late 1970s.

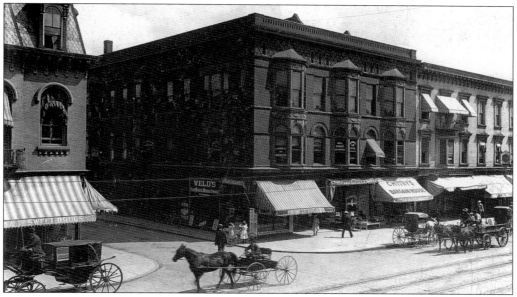

The Wheat Building, at the corner of Seneca and Linden Streets, was built after 1892. This photograph was taken sometime between 1895 and 1903. A.J. Sweet Drugs and Chitry's Bargain House appear in both the 1895 and 1903 City Directories. F.M. Chitry operated a household furnishings store on this site. The block burned in 1904 and again in the 1950s.

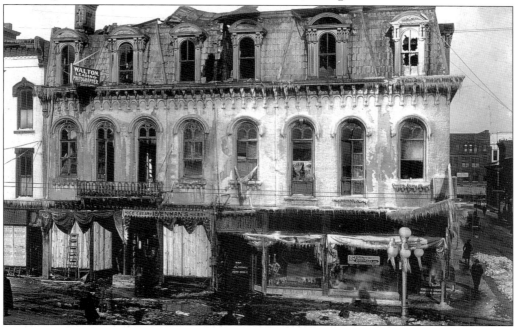

The Smith Block, a late-19th-century Second Empire-style building, stood on the corner of Seneca and Linden Streets. It burned on March 18, 1904, taking a woman's life. Snow and ice indicate a long winter. Isenman's later moved to Castle Street. A drugstore was located on this corner until 1960. Now known as the Guard Block, the building has remained in the Guard family since 1924.

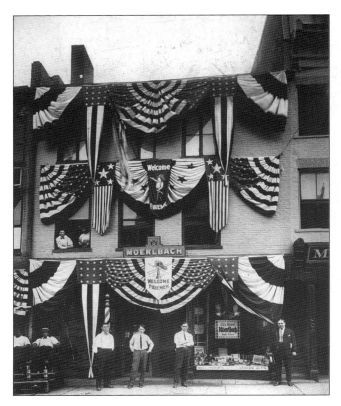

Geneva hosted many regional and state firemen's conventions in the 20th century. This festive photograph shows firemen being welcomed to Geneva c. 1900. The men in front of the building at 23 Seneca Street, from left to right, are Theodore Derby, Art Kenney, Willis Loftus (who operated a barbershop at 21 Seneca Street), two unidentified people, and "Bounce" Long. The business in the center was the Peck & Beebe Café.

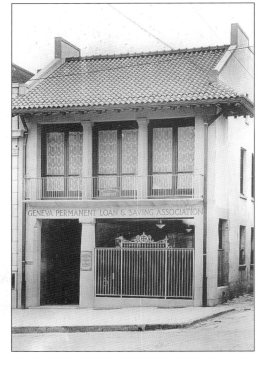

The Geneva Permanent Loan & Savings (later Geneva Federal Savings and Loan) moved into this location at 89 Seneca Street in 1914, when city offices vacated the building for the new city hall on Castle Street. Redesigned by local architect I. Edgar Hill, the bank advertised itself as "the building with the green window bars," to assure people that their money was safe. This distinctive building was razed in 1966 during urban renewal.

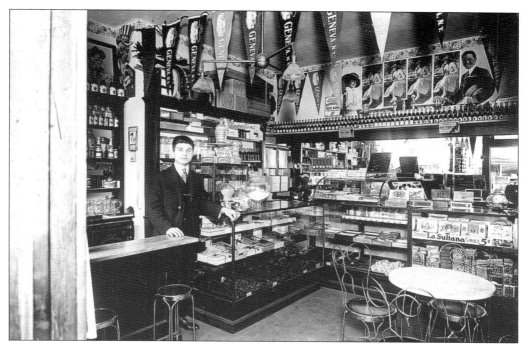

Edward J. Smaldone came to Geneva from Salerno, Italy, in 1912. After selling newspapers on the Geneva–Williamsport, Pennsylvania train for three years, he opened his own news and candy store in late 1915. This view shows the interior of the store, at 417 Exchange Street in the Temple Block, with Smaldone proudly standing at the counter. The business remained in the Smaldone family until it closed in 1996.

Main Street in Geneva has always been less commercially developed than most American Main Streets. The exception is the block between Seneca and Castle Streets, where Edwin McGreevy stands in front of his tire and battery store. Pictured c. 1922, this building became Cooley's Bar and Grill in 1935 and remained so for more than 60 years.

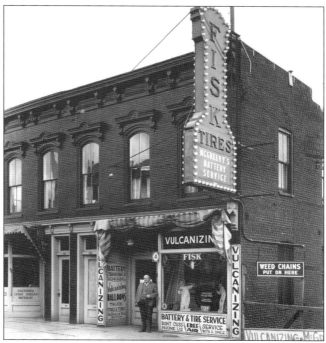

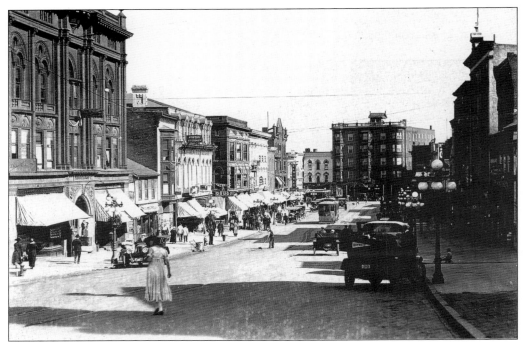

These two views of Seneca Street, taken more than 20 years apart, show numerous changes. The 1937 photograph (below) shows that the Schine's movie theater chain has purchased the Smith Opera House. The c. 1914 photograph (above) shows the Prouty Building, with its false cornice, and the five-lamp streetlights. Notice the changes in modes of transportation; by 1937, the trolley cars were gone but the tracks remained.

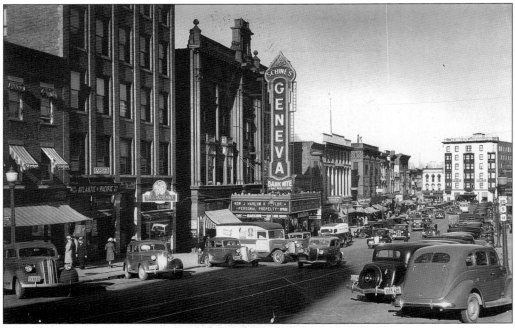

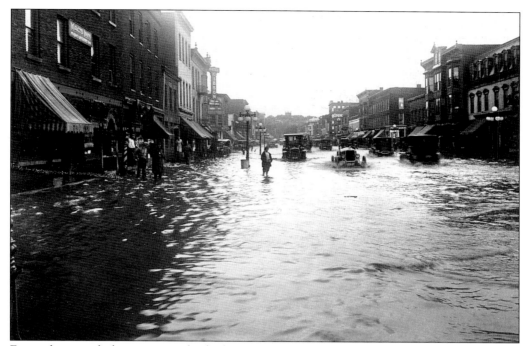

Every photograph documents multiple things: architecture, clothing and automobile styles, and names and types of local businesses. The main subject of this Exchange Street photograph is the flood of 1922, when Castle Creek overflowed its banks, flooding all the streets in its path.

The Miliken Electric Talking Lamp was installed at the intersection of Seneca and Exchange Streets in 1925. It was intended to help tourists find their way through the city. The need probably stemmed from the increasing prevalence of automobiles and the resulting congestion in downtown.

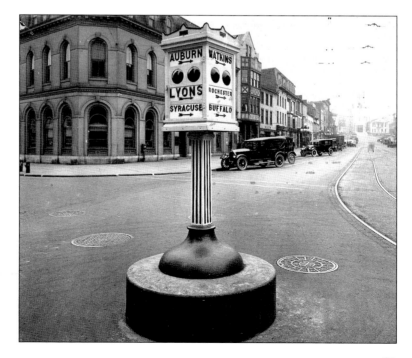

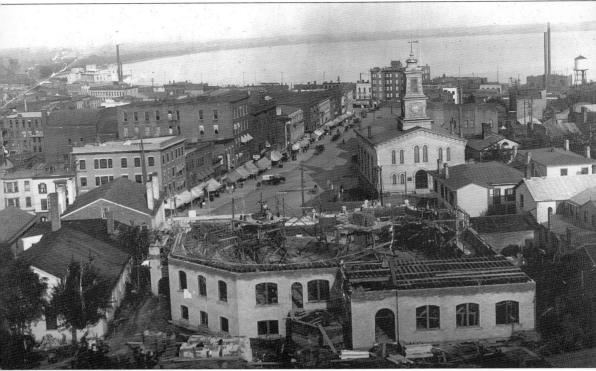

This photograph of downtown was probably taken from a rooftop c. 1912. The aerial view, looking toward the lake, shows a vibrant mix of churches, retail shops, and manufacturing industries. The core of downtown Geneva is defined by Seneca Street (center), Exchange Street (running parallel to the lake), and Castle Street (left of Seneca). Shown are the construction site of the new Methodist church (foreground) and the old Methodist Episcopal church (with the steeple and clock tower). The industrial and commercial buildings (to the right of the old church, toward the lake) were torn down in the 1960s as part of urban renewal, to make way for a parking lot.

Two

INDUSTRIAL PURSUITS

Agriculture has always provided a strong base for Geneva's economy. Because of the lack of waterpower, the Industrial Revolution did not arrive in Geneva until the latter part of the 19th century, with the advent of electricity. Geneva was home to numerous major industries until the middle of the 20th century, when mergers and the migration of industry to the South took its toll.

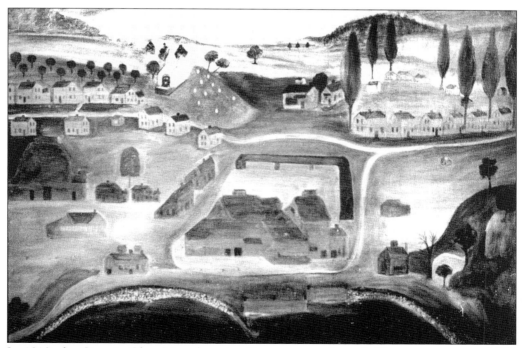

In 1810, the Ontario Glass Manufacturing Company was formed. The company owned 300 acres for the factory and 1,500 acres of woodlands. This *c.* 1820 image shows the community that developed around the glasshouse: sheds, an office, a church, a school, a store, and houses for laborers. The company operated from 1810 to 1830 and reopened from 1841 to 1847. This site on the lake is still known as Glass Factory Bay.

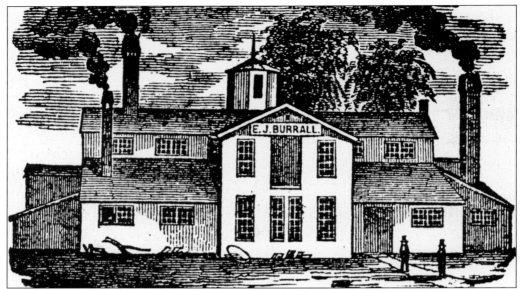

Shown is the E.J. Burrall Manufacturing Company c. 1835. Until 1851, Burrall's foundry was the only industry within the city's limit. Thomas Burrall established the business c. 1812. The firm produced farm implements such as threshing machines, corn shellers, grain reapers, and an English-derived drill that applied seed and manure in a single operation. It is said that Burrall produced the first cast-iron pipe to replace the city's wooden water pipes.

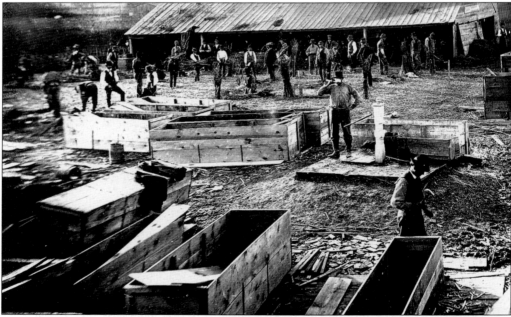

The nursery business was a contributor to Geneva's economy from the 1850s to the 1990s. With capital of $500, R.G. and G.H. Chase established the Chase Nurseries in 1866. This c. 1870 photograph shows the packing sheds on Pulteney Street. Each box measured 2.5 feet by 10 feet and, when filled, weighed as much as 1,000 pounds. Geneva's nursery products were known around the world.

In 1848, Thomas Maxwell, with his brothers Joshua and Henry, established Maxwell Nursery, Geneva's second nursery. This *c.* 1880s photograph shows the Maxwell office at the corner of Castle Street and Maxwell Avenue. Notice the mature trees adjacent to the building. By 1875, more than 8,000 acres in and around Geneva were devoted to the growing of flowers, shrubbery, and fruit, shade, and ornamental trees.

William, Thomas, and Edward Smith founded Geneva's first nursery, W. T. & E. Smith Nurseries, in 1846. The nursery remained in business until the 1960s. By 1895, Geneva had more than 30 nursery firms. Prof. William R. Brooks took this *c.* 1890 view of Smith Park from his observatory. William Smith created the 25-acre park between upper Castle and North Streets. After World War II, the park was divided into building lots.

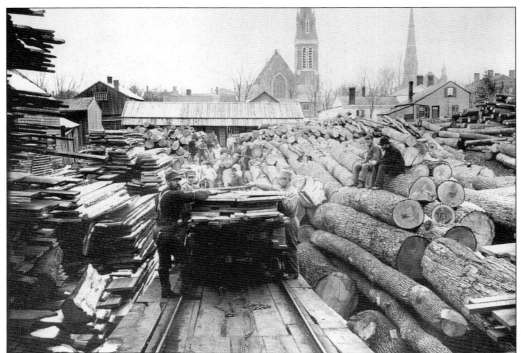

The nurserymen also sowed seeds of commercial growth. As early as 1859, Thomas Smith established the Geneva Steam Bending and Spoke Works of T. Smith at 294–296 Exchange Street. The company produced spokes, rims, and shafts for carriages, and all kinds of bent work for the local community and customers in other states. This 1880s view looks west toward St. Peter's and North Presbyterian Churches.

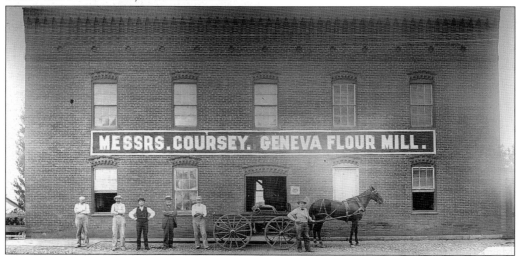

There were many Geneva companies that processed the area's harvest. Stephen Coursey, son of Irish immigrant Patrick Coursey, built the Geneva Flouring Mills in 1877 on South Exchange Street. An 1895 newspaper article notes that the mill was the best equipped in this section of the state, producing 125 barrels of flour per day. The company's Gold Dust brand flour was known for its quality throughout New York State and beyond.

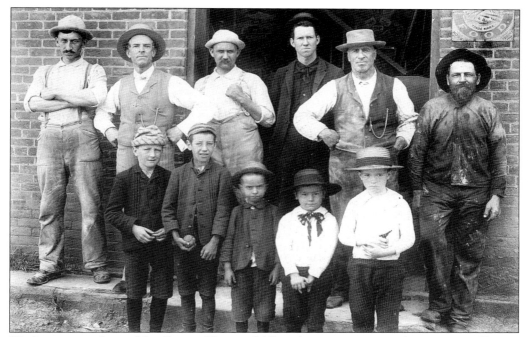

Workers pose in front of the Geneva Flouring Mills—their attire is certainly interesting. Do you think the children also worked in the mill?

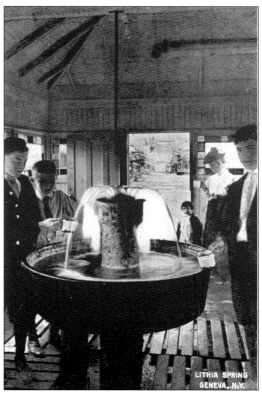

Stephen Coursey discovered a mineral spring behind the Flouring Mills in 1885, a time when mineral water was a popular remedy for everything from rheumatism to kidney disease. From the spring, Coursey developed and operated the Geneva Magnetic Lithia Mineral Springs. Geneva's water won an award at the 1901 Pan-American Exposition. By the 1920s, the spring produced 350,000 gallons per day and Geneva Mineral Water was shipped around the country.

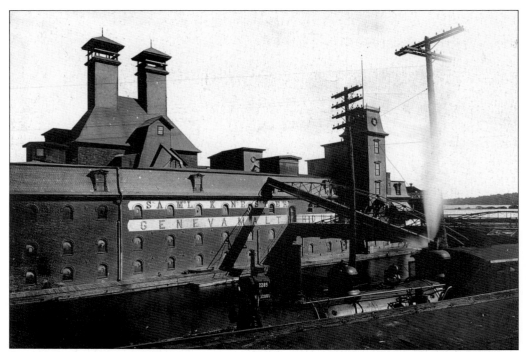

Samuel K. Nester bought the Geneva Malt House in 1870. It operated for 40 years on the south side of the canal near the lake. What is malt? It is the product of steeping barley and allowing it to germinate, and it is used to produce beer. Nester had one of the largest operations in the country, processing 350,000 bushels per year. At Christmas, each employee received a 100-pound sack of flour.

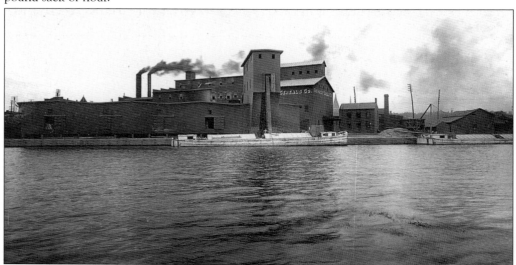

In 1892, an abundance of grain and the transportation network brought the Patent Cereal Company to Geneva's harbor from Brooklyn. The operation continued on the lakefront until it closed in 1963. The company manufactured a variety of brewer's supplies and corn products. By 1925, the company billed itself as the "largest manufacturer of dry paste flour in the world." Brand names included Rex Dry Paste (wallpaper paste) and Dic-A-Doo brush cleaner.

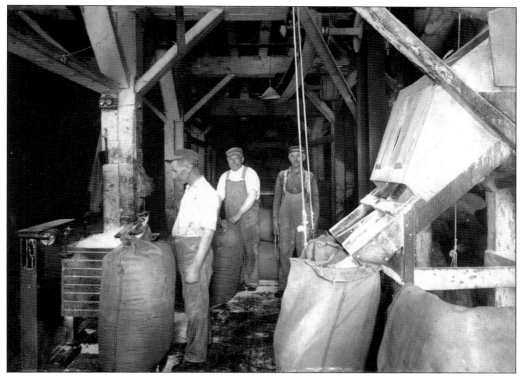

A total of 75 people worked at Patent Cereals in 1912, producing 150,000 bushels per day. The interior was nothing fancy, but it sure was dusty. There were no unions at the time, and each employee received a turkey at Christmas. The mill cast "a popcorn smell" throughout the community, and people kept time by the steam whistle, which blew at 7 a.m. and noon six days a week.

This c. 1912 photograph shows Geneva Cutlery Company, located in Torrey Park, Geneva's "Little Italy." Formed in 1902, the company was known for its Genco brand of quality straight shaving razors. At this time, employment was 200 and daily production was 3,600 razors. In 1934, Ekco Products bought the company and it became Geneva Forge. With the advent of safety razors, production changed to cutlery. The company moved in 1961.

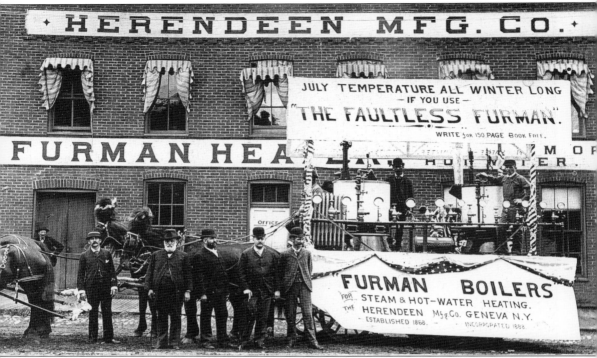

The Thomas Smoothing Harrow Company, established by Edward Herendeen in 1868, produced agricultural implements. By the time of this photograph, *c.* 1878, the company was known as the Herendeen Manufacturing Company and was located on the lakeside of South Exchange Street. It produced the Furman steam boiler, made of cast iron, with threaded joints. At the start of the 20th century, there were four companies in Geneva producing steam boilers. In 1910, the Herendeen Company became part of the U.S. Radiator Corporation, which was formed to manufacture steam boilers, radiators, and supplies. The company fell victim to the Great Depression in 1931, and the plant closed. It was retooled in 1943 for war production. After merging with the National Radiator Corporation in the 1950s, the plant closed in 1962. The buildings were demolished as part of the 1960s urban renewal project.

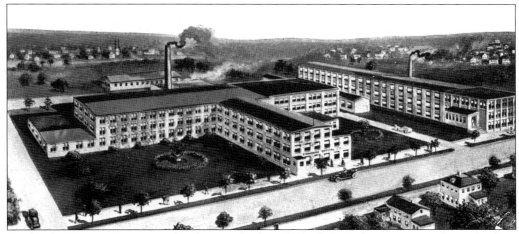

As local nurserymen accumulated capital, they looked for other ways to diversify their investments and to improve the economy. The names of Smith and Maxwell are prominent in the development of Geneva's optical industry. In 1873, Andrew Smith organized the Geneva Optical Company to manufacture spectacles and other optical goods. This *c.* 1909 photograph shows the buildings of Geneva Lens and Standard Optical. Geneva Lens (later U.S. Lens) produced lenses and optical machinery that were then sold through Standard Optical. Eventually the combined companies became known as the Shuron Optical Company, operating in Geneva until 1960. Shown below are women working in the steel room, probably making eyeglass frames. For years, the rouge from the grinding of lenses caused Castle Creek to run red.

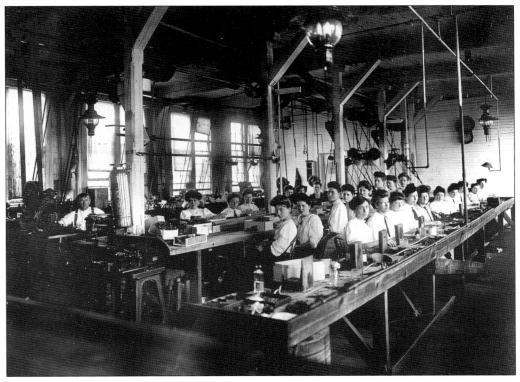

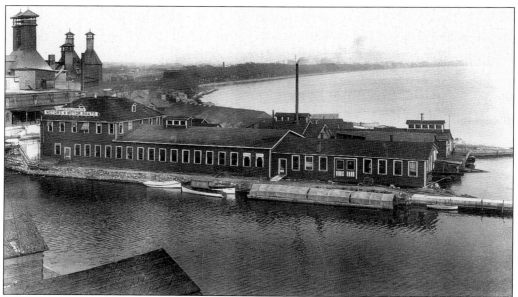

Walter Fay and and Ernest Bowen began business making bicycle parts in Auburn. By 1900, they were making motors and boats at separate facilities in Auburn. They moved to Geneva's harbor in 1904. This 1909 view of the factory, which contained 10 buildings, is looking east along the lakeshore (Nester's Malt House is on the left). Boats were tested right off the line. Their test driver, Joseph Hart, was completely deaf but could sense any vibrations that indicated engine problems. Fay & Bowen products were touted as "None Better Built" both here and abroad. Their boats were not inexpensive—a 1921 runabout sold for $1,450. Today, these boats are prized possessions. Shown below is the interior of the boat-building plant, where seaplane hulls for the Curtiss Aeroplane Company were made during World War I.

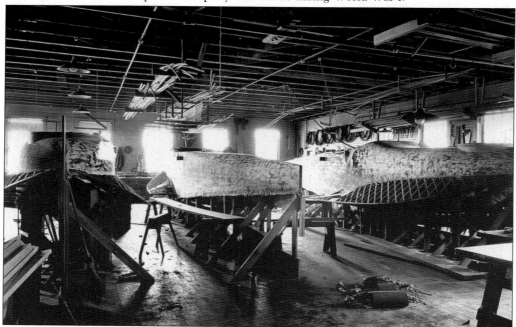

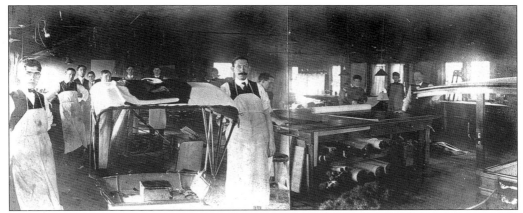

It seems that every small town had a wagon company. The Geneva Carriage Company was organized in 1891 and, in 1894, became the Geneva Wagon Works. This c. 1915 picture shows two of the company products. In the 1930s, the company became the Geneva Body Company, which sold an array of products on the international market—ambulances, wagonettes, and express and panel-top delivery wagons—until it closed c. 1939.

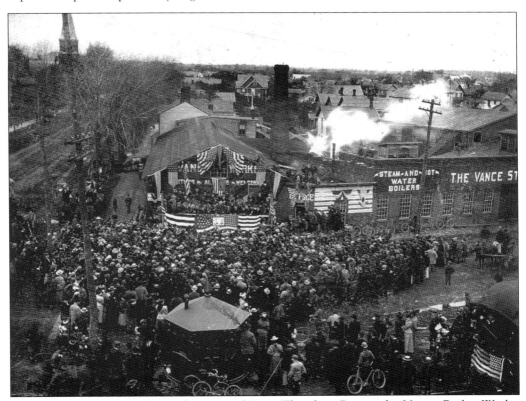

This 1904 photograph shows the visit of Pres. Theodore Roosevelt. Vance Boiler Works, founded in 1897 by James R. Vance, a Scottish immigrant, is on the right across from the New York Central Railroad Depot. In the 1920s, the company shifted from boiler making to boiler repair, which allowed it to survive the Depression. A descendant of the founder currently runs the company as Vance Metal Fabricators.

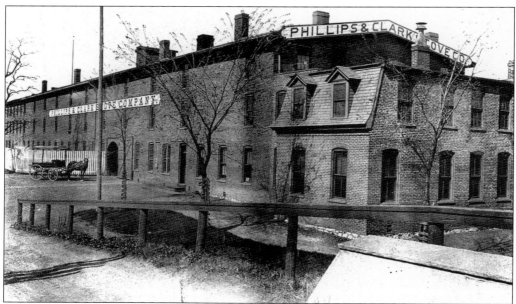

Like some other businesses, the Phillips & Clark Stove Company moved here from Troy in 1885. The early photograph (above) shows the foundry, on Evans Street between the canal and the New York Central Railroad. The company was noted for its Andes brand of cast-iron parlor and kitchen stoves, and in 1924, the company changed its name to the Andes Range and Furnace Corporation. In the 1930s, the company merged with the Summit Foundry and changed production to enamel-type kitchen stoves. The company's products were built to last; many Andes and Summit stoves are still in use around the country. The interior of Phillips & Clark's molding room (below) shows working conditions in an early-20th-century foundry: hot, sweaty, and dirty. The company closed its doors in 1951.

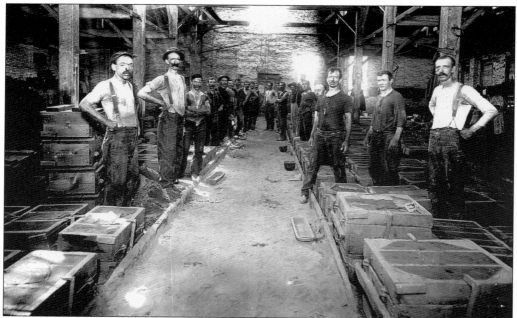

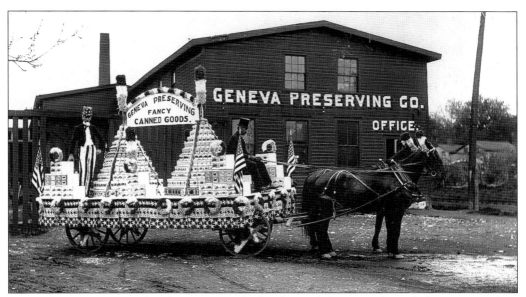

As food preservation technology improved, the demand for canned goods began to replace home-canning techniques. The Geneva Preserving Company, formed in 1889, continued in operation into the mid-20th century. Fruits and vegetables came from local farmers. This building burned in 1912, and the company rebuilt at the same location on North Street, next to the New York Central rail line. By 1929, some 1,000 people—mostly women and Italian Americans—worked here.

In the 1890s, Empire State Can Company was formed to support Geneva's food-preserving industry. In 1901, a total of 123 small companies consolidated to become the American Can Company. During World War I, the company made brass shell casings. This c. 1920 photograph shows the factory at 122 North Genesee Street, next to the Lehigh Valley Railroad, that was converted to a machine shop to produce machinery for the canning industry.

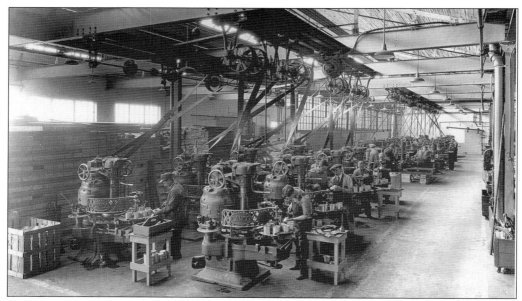

This early-1920s photograph of the American Can Company's testing floor shows where all can-closing machines were tested and adjusted prior to shipment. Notice the trademark Canco on the machines. During the Depression the company work plan of "one week on and one week off" provided as many jobs as possible. American Can was a major Geneva employer for nearly 100 years.

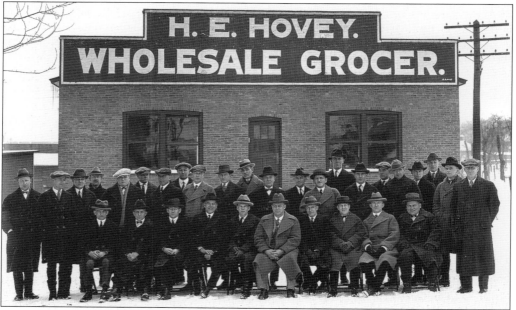

Harry Hovey started the Market Basket grocery chain in the town of Warsaw. By 1915, there were two stores in Geneva, and by 1940, there were ten. This *c.* 1921 photograph probably represents management and salesmen opening a separate business at 55 State Street. Because of its central location, the Market Basket's distribution center moved to Geneva in 1928. The chain of over 100 stores was sold to American Stores in the 1950s.

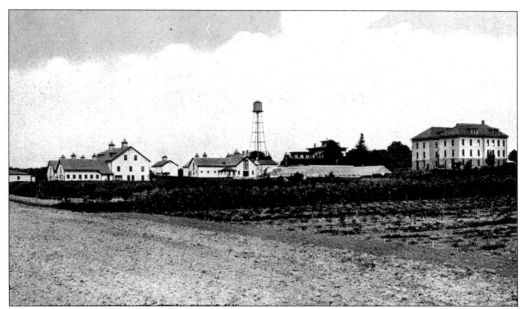

In the 1880s, leading farmers, agricultural organizations, and the Grange lobbied the state legislature to establish a facility "to promote agricultural interests through scientific investigations and experiments." In 1882, Geneva was chosen as the site for such a facility and the state purchased the 130-acre Denton Farm, on North Street west of Castle Street. It was often referred to as "the state farm." In 1923, the station became part of the College of Agriculture at Cornell University. The New York State Agricultural Experiment Station is recognized throughout the world for its work in plant pathology, entomology, and the development of new varieties of fruits and vegetables. These views were taken c. 1911. One shows the original farm buildings and greenhouses and the other is Sturtevant Hall, the 1898 biology and dairy building. The station carried on a dairy program from 1882 to 1943.

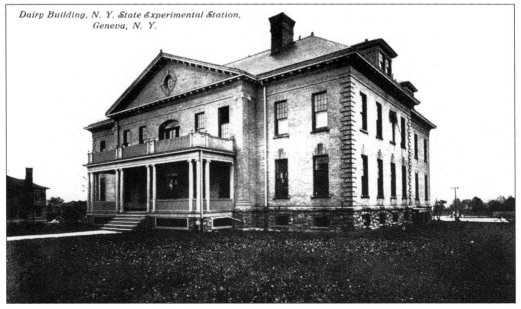

Dairy Building, N. Y. State Experimental Station, Geneva, N. Y.

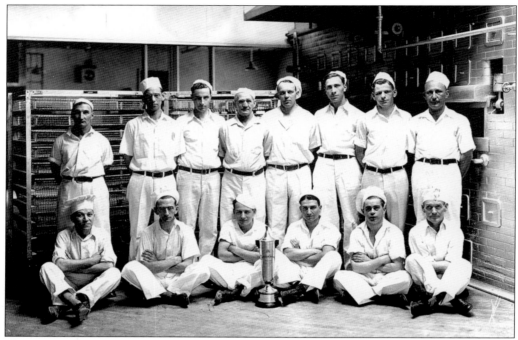

Shown is "the Bakery Bunch," with a trophy for a competition they won in 1932. The Geneva Baking Company was formed in 1911 and, by 1915, had moved to 248 Exchange Street. Henry Fisher (back row, fourth from the left) worked at the bakery from 1928 to 1945 and retired at age 73. The bakery, which closed in the 1960s, was noted for its Butterfly potato bread and Sunbeam bread.

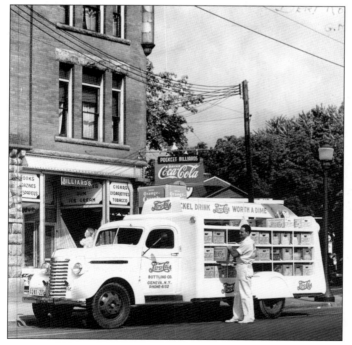

Bert Robinson, delivery driver for Geneva Club Bottling Company, makes a stop at the corner of Main and Milton Streets in 1939. In 1918, Achilles Michael Anania traded his Indian motorcycle for the Carney's Bottling Works and renamed the company Geneva Bottling Works. In 1939, the company obtained the Pepsi-Cola franchise for Ontario and Yates Counties. Anania's sons now operate the company as Geneva Club Beverage Company. (Courtesy of Robert and Ronald Anania.)

Three

MOVING ABOUT

Geneva's central location created a hub for land, water, and railroad routes. By 1797, "the great road to Utica" was finished and provided stage service between the two towns. Water was the first and best transportation. The sloop *Alexander* in 1796 provided regular service up and down the lake. By 1813, the Seneca Lock Navigation Company "was formed to improve and make navigable the outlets of Seneca and Cayuga Lakes." By 1828, this canal was connected to the Erie Canal. In the 1840s, railroads appeared and presented better ties to the rest of the nation.

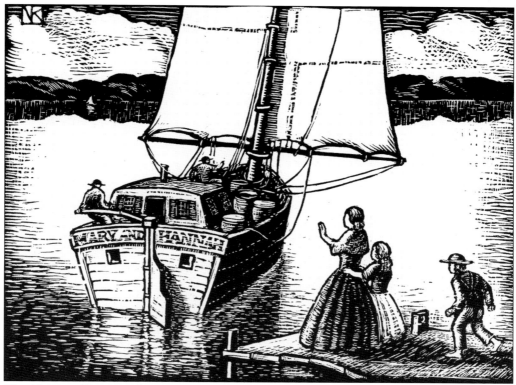

This Norman Kent woodcut is of the *Mary and Hannah*, a 70-ton schooner, the first vessel to transport goods from Seneca Lake to New York City by the Erie Canal. A load of wheat, butter, and beans from this area arrived in New York City on November 17, 1823. The ship's owners, John H. Osborne and Samuel S. Seely, received a silver trophy from 10 flour manufacturers to commemorate the event.

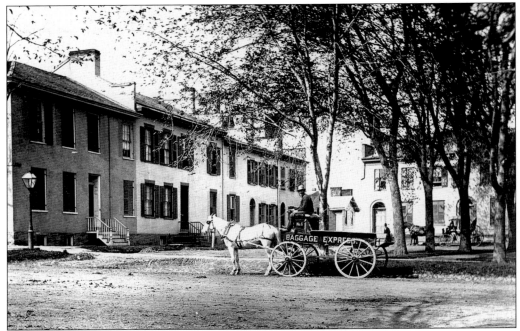

Little is known about this Jonathan Vail photograph of the Baggage Express wagon. Geneva had numerous wagons for hire. The 1899 Directory lists 2 express companies, 7 hackmen, 11 draymen, and 3 liveries. Just like today, some people felt it easier to call for a ride than maintain their own horse and wagon or carriage. This photograph was taken on the south corner of Pulteney Park.

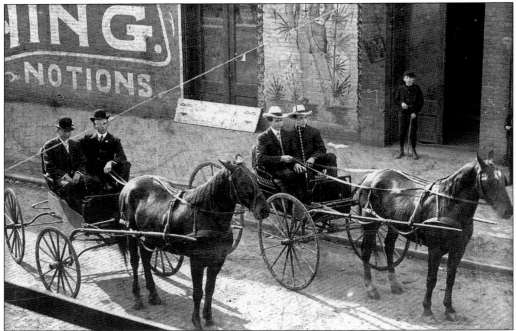

What's going on here? Is this an early rendition of a drag race? Look at the matching hats.

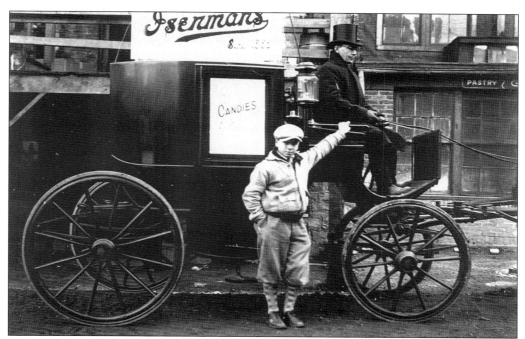

Wagons, like cars, came in all styles for all purposes. This coach may have been used as a promotional vehicle, as well as for family transportation. The man in the driver's seat is probably Lewis Isenman, who established the ice-cream and confectionary store at 64 Seneca Street in 1901. By 1923, the store had moved to 150 Castle Street and was operated by Louis Isenman (probably Lewis's son). In 1929, Clinton Tills worked at Isenman's as a clerk; he later became an owner. Isenman's ice-cream parlor was a favorite hangout for several generations of Genevans.

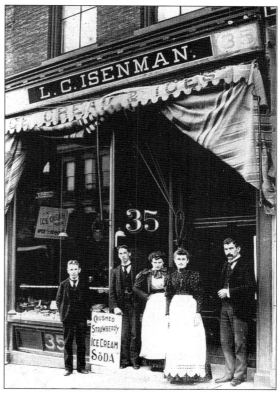

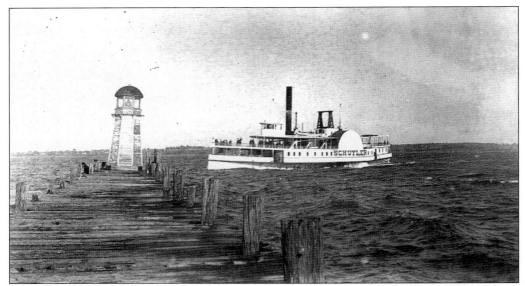

This pier, called Lighthouse Pier, was built in 1868 as additional protection for the harbor from the lake's sometimes treacherous waters. Before its demolition in the 1980s, the pier had supported three different lights. Off of the pier is the steamboat *Schuyler* (1872–1915). This 175-foot steamer was built with enough cabins to shelter all of its passengers. The first steamboat, the *Seneca Chief*, appeared on the lake in 1828.

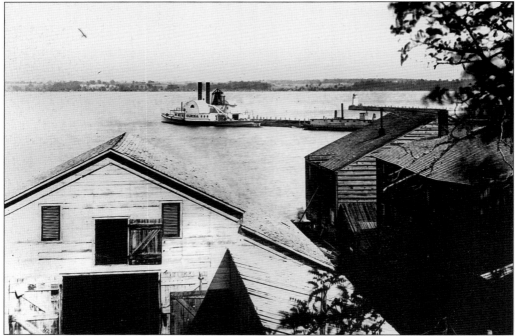

The *Elmira* is seen in this photograph taken from the Franklin House c. 1872, looking to the east. The boat was constructed at the end of Castle Street by Benjamin Springstead and launched in 1862. It was 225 feet long and had a double paddle wheel. It was built as a towboat to move canal boats down the lake. Passengers were secondary.

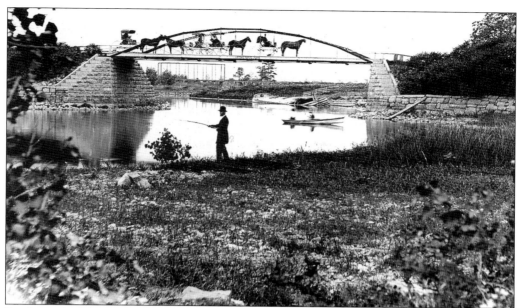

By the end of the 19th century, multiple modes of transportation coexisted: carriages, trains, and boats. Geneva had a number of bridges over the Seneca-Cayuga Canal. This one extends the Lake Road to the east over the outlet at the northeast corner of the lake. When the Barge Canal supplanted the Erie Canal, this became the main entrance to the Seneca-Cayuga Canal. There was a bridge here until the 1960s.

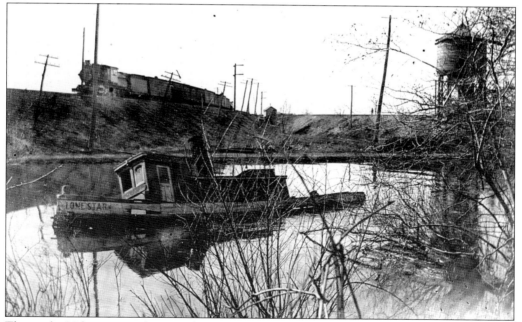

This early-20th-century photograph captures the shift in transportation technology. Geneva's water routes were prized during most of the 19th century, but they became less important as the railroads moved in. Shown is a former tugboat, left to rot in the canal as a train rolls by. Boats of this type were used to gang the canal barges behind the steamboats.

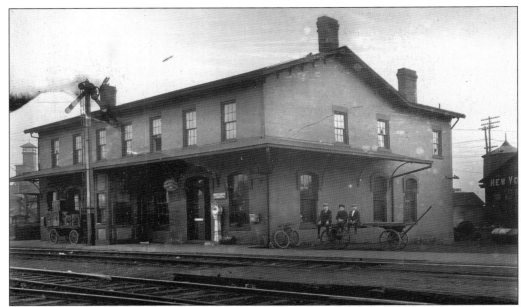

Geneva's first railroad appeared in 1841, the Rochester and Auburn. This became part of the New York Central system in 1853 and was known as the Auburn Branch of the New York Central and Hudson River Railroad. The New York Central rail yard was north of the harbor at the end of Lewis Street. This photograph shows the passenger station in 1872. This building was replaced with a new station in 1907.

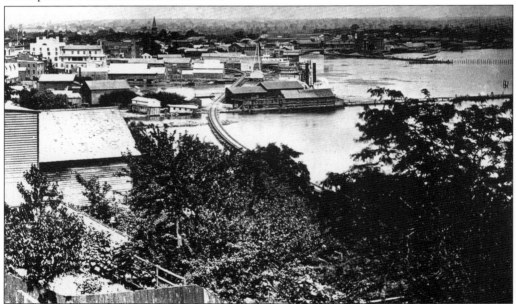

The Syracuse, Geneva, and Corning Railroad was a division of the New York Central, created in 1875 to bring coal north from the Fall Brook coal fields in Pennsylvania. There was a pitched battle between railroad proponents and South Main Street residents who did not want the smoke, noise, and loss of lake access. This photograph, c. 1878, illustrates the compromise: the tracks ran north over the water on a wooden trestle.

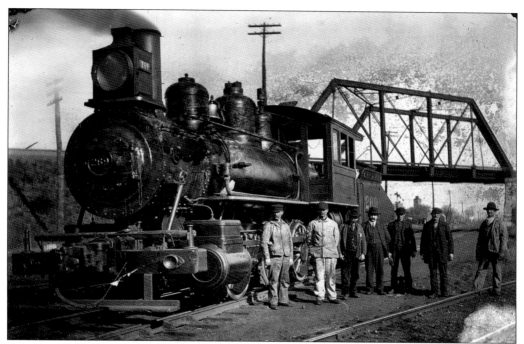

Taken in 1903, this photograph shows New York Central Engine No. 269 and the rail yard. The yard was located north of the end of the lake. This view is looking north, with the Lehigh Valley Railroad bridge in the background.

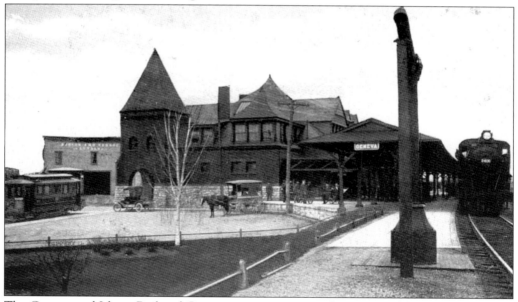

The Geneva and Ithaca Railroad Company was incorporated in 1870 and later became part of the Lehigh Valley Railroad. This early-1900s view shows the Geneva station, built in 1892–1893. It was Lehigh Valley's largest and most ornate station, one of three with a restaurant. Fortunately, the building still stands. The Lehigh Valley line was noted for its Black Diamond Express, which, from 1896 to 1961, ran from New York City to Buffalo.

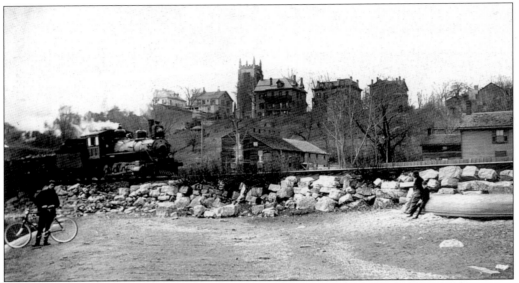

This early-20th-century image by photographer Hammond B. Tuttle (1868–1950) captures three modes of transportation: boat, bicycle, and steam locomotive.

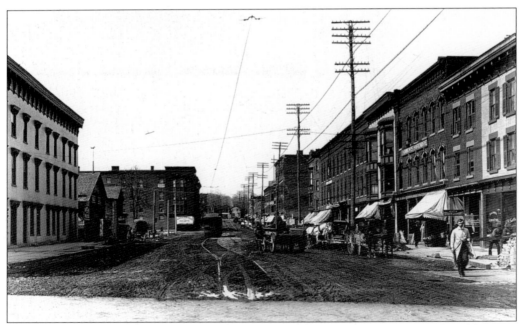

Everyone loves to complain about road conditions, rarely stopping to count their blessings. Castle Street *c.* 1905 was far worse than what we have to contend with today. Taking the trolley, with its steel rails, looked like the best bet for a clean and somewhat smooth ride.

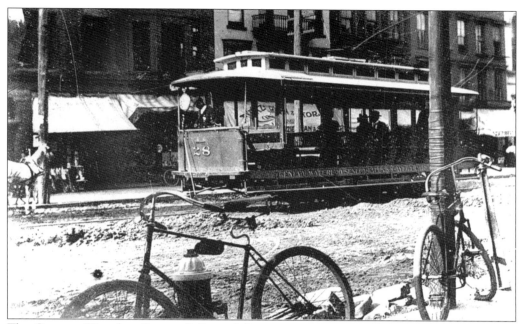

The Geneva, Waterloo, Seneca Falls, and Cayuga streetcar system began operation in 1894. This 1901 view of Seneca Street indicates that the street railway offered easy interurban transportation. Safety bicycles came in c. 1890. A bicycle was not the best ride in the world, nor the cleanest (note the lack of fenders), but it did free a person from relying on the family horse or waiting for a trolley.

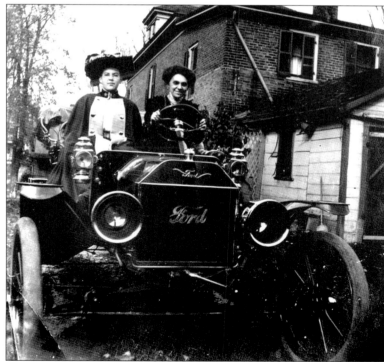

These women are out for a drive in a Model T Ford c. 1915. Although women could not vote at that time, they could drive. Notice the touring outfit.

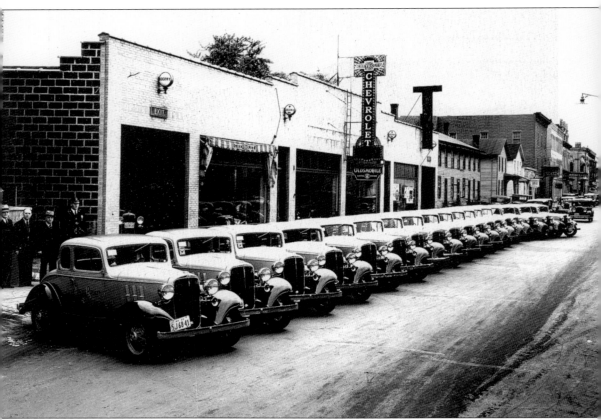

What a great sale in the depth of the Great Depression: eighteen 1933 Chevy five-window coupes for the Market Basket Corporation. Undoubtedly, management at the Market Basket wanted the salesmen to have the latest in automotive technology. It is said that at one point, the Market Basket grocery chain operated more than 200 stores in the central New York region. The Russell-Hart Agency operated on the west side of South Exchange Street, at 604–612. The dealership remained at this site until the 1960s, when the buildings were demolished to create a parking lot.

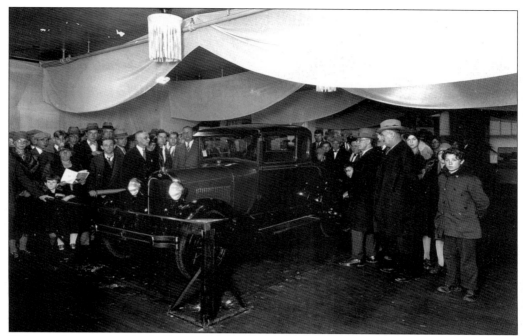

This was the scene inside the Burton Adams Garage on December 8, 1927. The occasion was the unveiling of the new Model A Ford. The Adams Garage was in the former Methodist Episcopal church on the southeast corner of Main and Seneca Streets. During World War II, the building was a United Service Organizations (USO) facility; later it became a civic center.

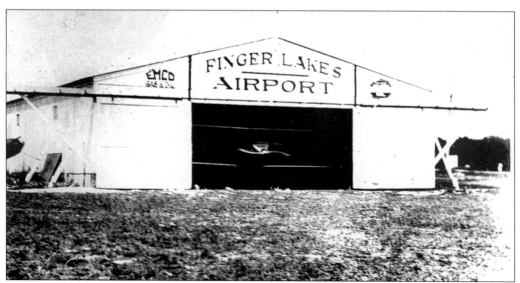

Aviation became a popular hobby in the 1920s. A number of airfields were developed around Geneva during the 1930s and 1940s. The Finger Lakes Airport was located west of Geneva on the William Fordon Farm, on Canandaigua Road (Route 5 & 20). This photograph was probably taken in the late 1920s.

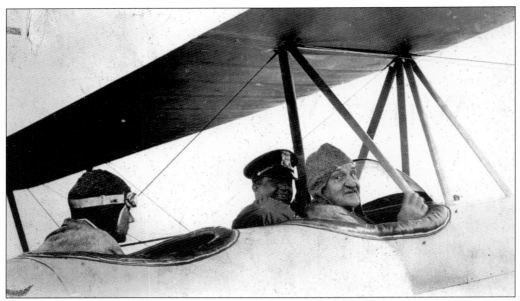

This undated photograph shows, from left to right, Charles Wetheran, aviator; Henry Spears, officer and owner of Green Meadows Riding Stables; and George Ditmars (1862–1942), city judge. It appears that the airplane is a Curtiss Jenny, used in World War I and easy to obtain after the war.

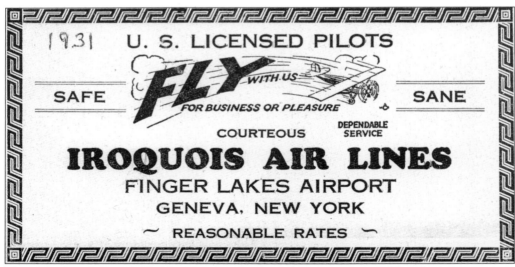

This airline must have had a short life because no information is available. The company only appears in the 1931 City Directory. Safe, sane, and courteous—who could ask for more from an airline today?

Four

WHAT WE LEARNED IN SCHOOL

Education has always been important in Geneva. The Geneva Academy was among the first institutions to be established when Williamson developed the town in 1796. Scores of private schools followed the academy, and public education was begun in 1815. The founding of the forerunner of Hobart College in 1822 and William Smith College in 1908 created a new identity for Geneva: a college town.

Walnut Hill School for boys accepted boarding and day students from 1852 to 1875. Rev. Dr. Thomas Reed was the principal for much of that time, offering three 16-week terms during a school year. This building was demolished *c.* 1880 and replaced with what eventually became Houghton House of Hobart & William Smith Colleges.

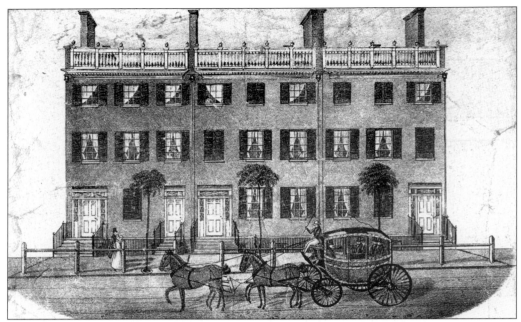

Elizabeth Stryker Ricord ran the Geneva Female Seminary from 1829 to 1842. This drawing by Henry Walton shows the school at 387, 391, and 395 South Main Street in the 1830s. The Geneva Female Seminary was similar to other secondary schools for young women, but differed in certain ways: the curriculum did not include domestic subjects; reasoning was emphasized over memorization; and languages, sciences and advanced mathematics were offered.

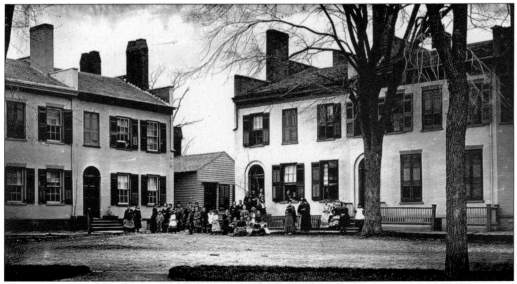

Women and girls gather outside Black's School for Young Ladies. Mrs. M.J. Black and Miss S.W. Black operated a "select school" at 15 Park Place from 1873 to 1880. This view of the southwest corner of Pulteney Park was taken in the 1870s.

The Bridge sisters founded the DeLancey School for Girls c. 1856. The original school was at 629 South Main Street. The Bridges left Geneva c. 1868, returning to reopen the school in 1880. The school moved to the home shown here on DeLancey Drive in 1891 and came under the direction of Mary Smart. Records indicate that the DeLancey School closed in 1912.

Charles Bean, an imaginative lawyer, created the Endymion Military Preparatory School in 1884. It had brochures, diplomas, and "alumni," but some say the school only existed on paper and in Bean's mind. These unidentified "students" are shown outside Elmwood Priory, one of the school "buildings" Bean built behind his home, Maple Hill. Endymion Military School closed in 1917 (if, indeed, it had ever been open); Maple Hill later became the Lafayette Inn.

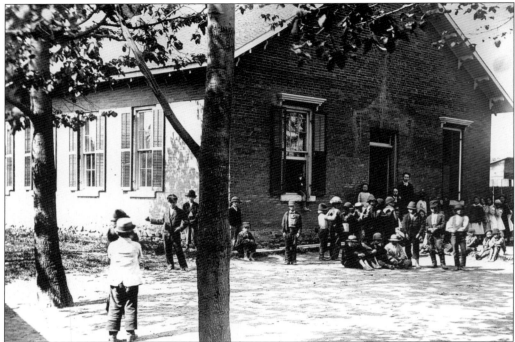

The East Branch School on Jackson Street was a far cry from the private schools on the south end of town. The bare feet on some of the children may have been a fashion choice but more likely indicated a lack of money for shoes. The interior of the school was adequate but austere. This public school was probably built prior to 1850; it had closed by 1884 and was sold off in 1888. The other branch schools were on Cortland Street, Lewis Street, and High Street; African American children were segregated at High Street until 1863.

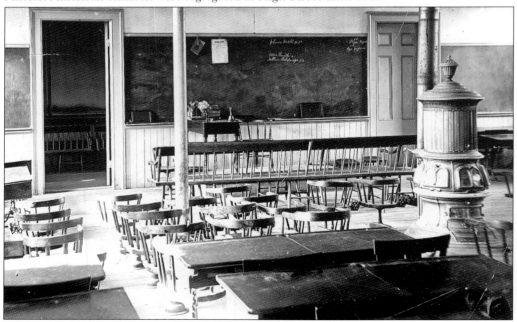

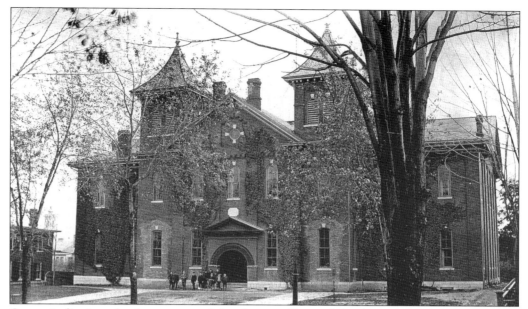

Geneva's district schools were consolidated into a Union School in 1839. The original four-room building on Milton Street was expanded several times, but the formation of branch schools was necessary by 1853 to accommodate all students. The first building burned in 1868; the building shown here was completed in 1870. The addition of classical instruction and normal classes qualified the academy as the Geneva Classical & Union School.

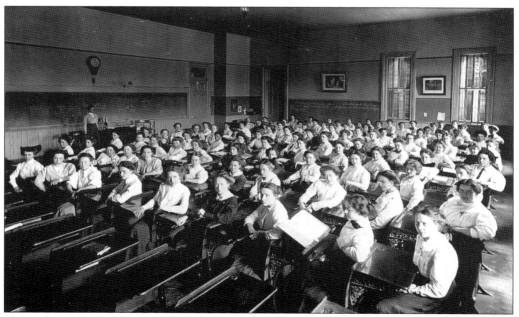

This girls-only interior view of the Classical & Union School is identified as "Miss Parker's Room 1911 or 1912". A 1957 newspaper article recalls that "boys to the left, girls to the right" was a rule enforced when marching to class and assembly in Geneva Classical & Union School.

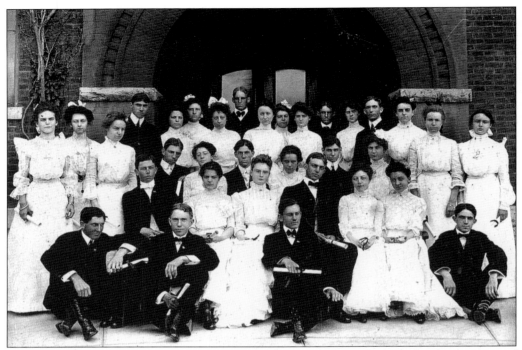

Apparently the sexes were allowed to mingle for this graduation photograph taken in front of the high school in 1902.

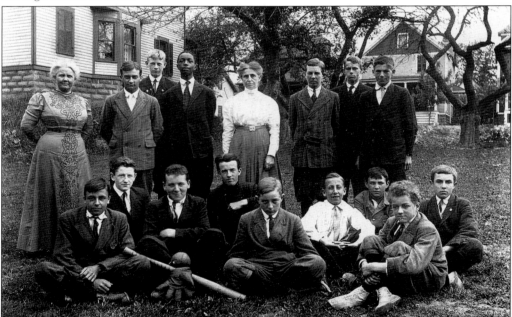

The occasion for this photograph of eighth-grade boys outside Lewis Street School is unknown. It was probably taken prior to 1925. The new high school on Pulteney Street was completed that year, and the older grammar school students began attending junior high at the old Classical & Union building.

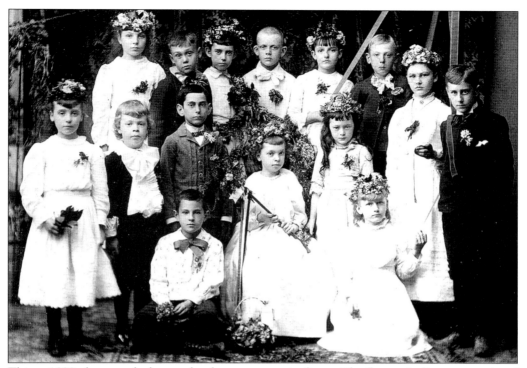

This *c.* 1892 photograph shows school pageantry at its finest. The flowers indicate some rite of spring perhaps; is the girl in the center the May Queen? The Geneva schools held an annual field day in early June when each grade would present a folk dance or drill.

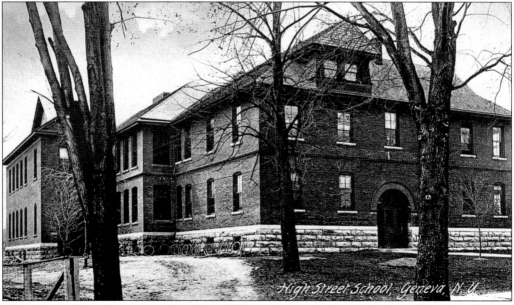

High Street School was completed in 1890 and expanded several times. The first Parent-Teachers Association in the city was formed at the school in 1917. The school closed in 1955, then was reopened in 1960 and used until the 1980s.

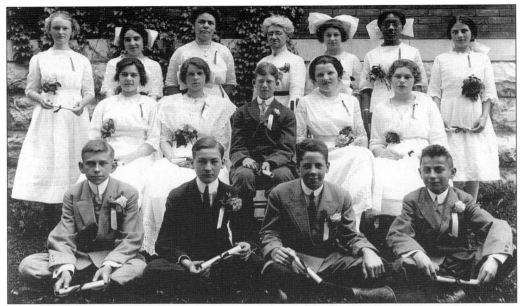

This 1913 High Street School group may have been the eighth-grade graduating class. Completing the eighth grade was a significant event, as each student received an eighth-year certificate indicating proficiency in all the basic disciplines. For many years, the eighth-grade certificate was required as proof of education for voter registration, regardless of any higher degree.

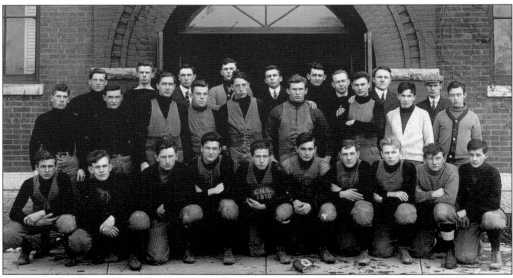

The Geneva High School 1910 football team was a dashing crew, in vests and padded pants. From left to right are the following: (front row) Henry Clise, Arthur Lydon, Larry Thornton, Deake Welsh, Harold Rauf, H. Edmond Wirtz, Charles Beard, Will Thornton, Chester Carrol, and Bill Hoefler; (middle row) unidentified, Albert Kane, Newton Hubbs, Joe Dinan, Bob Jolly, Wallace Swartout, Ed Tills, John Rogers, and Amos Debott; (back row) unidentified, ? Goodwin, Carollton Webster, Wilson Buckholz, Richard Levitt, Reginald Wilson, Tom Rogers, Mr. Evans, and Bill Kane.

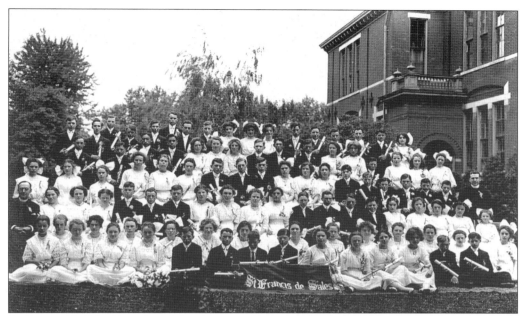

St. Francis DeSales Parochial School was established on Exchange Street in 1875. St. Stephen's Parochial School was formed in 1904 when that parish was created to serve the south side of Geneva. DeSales was granted high school status by the state of New York in 1913, cementing the parochial elementary and secondary schools we know today. The year of this photograph is unknown, but it was taken outside the old school.

The first North Street School was built in 1927–1928 at 252 North Street. It was the last of the classic school buildings before the era of modern construction took hold in the 1950s. A modern junior high school was built at 400 North Street in 1957; it became North Street Elementary after the junior high moved to the old high school. This building was torn down to make way for Geneva General Hospital's medical arts complex.

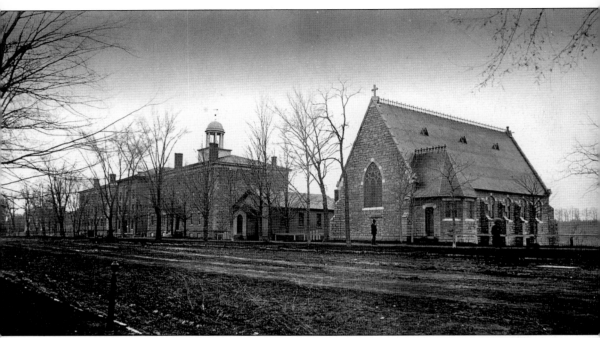

Geneva College was chartered in 1825 with the strong support of the Episcopal Church and Bishop John Henry Hobart. The bishop's work was commemorated in 1852 when the college's name became Hobart Free College; the "Free" was dropped in 1860. The original campus of the college was confined to South Main Street. This c. 1868 photograph shows, from left to right, Trinity Hall (1837), Middle Hall (1836), Geneva Hall (1822), original chapel, and St. John's Chapel (completed 1863). The chapel was designed by the noted Gothic Revival architect Richard Upjohn. Middle Hall was built to house the college's medical school, but the presence of cadavers in the middle of campus was not welcome. Plans began almost immediately for the medical college to move down South Main Street to a new building, away from the main campus.

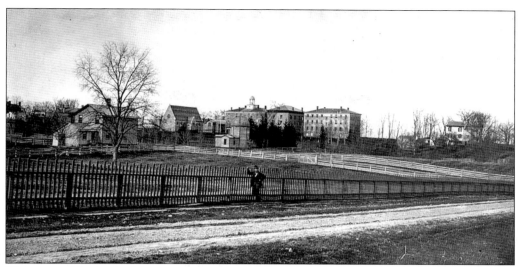

This view of the back of the campus may have been taken around the same time of the previous photograph. Aside from the observatory, built in the 1860s, the land behind the South Main Street buildings was undeveloped. The gentleman in the foreground was on St. Clair Street, and the house on the left was on Pulteney Street.

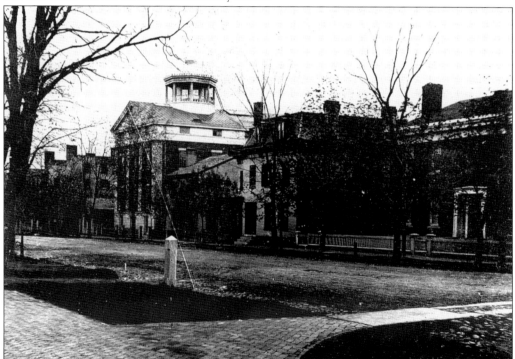

Geneva Medical College was organized in 1834 under Geneva College's charter and begun in Middle Hall. By popular demand, a separate building was constructed near 493 South Main Street in 1841, complete with domed skylight to illuminate the operating theater. Competition from other medical schools drew away students and faculty; in 1871, the books and equipment of the college were sold to Syracuse University. The medical college building burned in 1877.

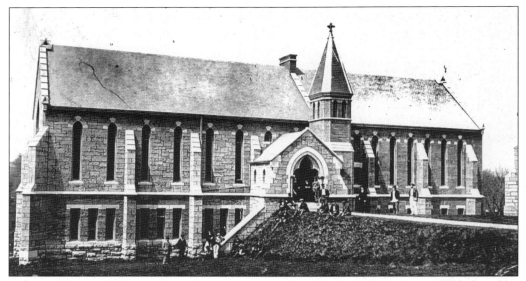

Hobart's library, built in 1885–1886, was designed by Richard Michell Upjohn, the elder Richard's son. The north extension (right) was designed by Dorchester & Rose after Upjohn's original plan and was added in 1894–1895. The library was named the Demarest Memorial Library in 1895.

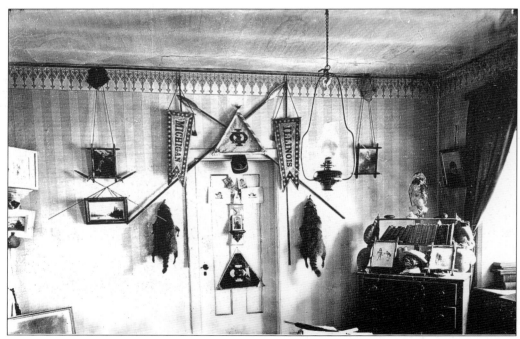

This was a student's room in Trinity Hall c. 1880. College dormitories are a reflection of both popular culture and personal taste. What does this photograph say about the time and the student?

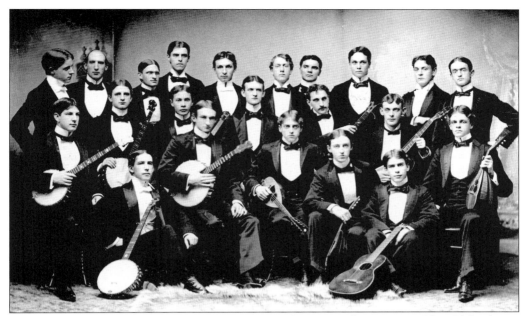

Sadly, some Hobart traditions have been lost over the years. The Banjo & Glee Club, shown here in 1893, is one institution that is no more. Note the round "potato bug" mandolins. (Courtesy of Hobart & William Smith Colleges Archives.)

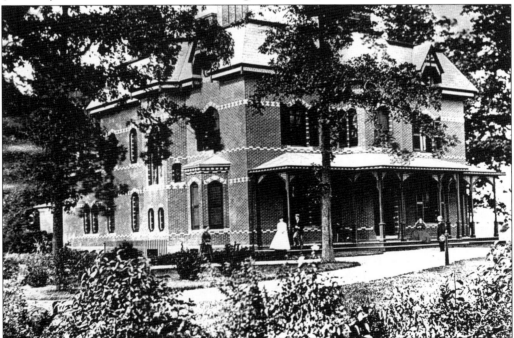

William Smith College opened in September 1908 with 19 students. The William B. Douglas House, another Upjohn design, was purchased and converted to the first college dorm and named after Elizabeth Blackwell, the Geneva Medical College graduate who was the first woman in the United States to receive a medical degree.

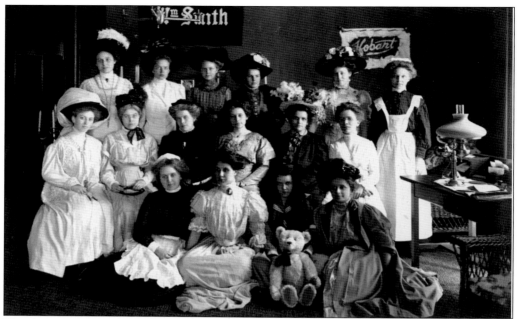

The first two plays presented at William Smith College were given in the old dining room of Blackwell House on March 29, 1909. Among those pictured are cast members Catherine Oaks, Isabel Long, Emily Smith, Ruth Young, Ermine Yerkes, Jennie Cumming, Martha Nugent, Elizabeth Giddings, Frances Eddy, Reba Antonides, Marie Sporer, Marion Dingley, Helen Addison, Laura Tulett, Mary Lyon, Daisy Weeks, and Evangeline Keefe. (Courtesy of Hobart & William Smith Colleges Archives.)

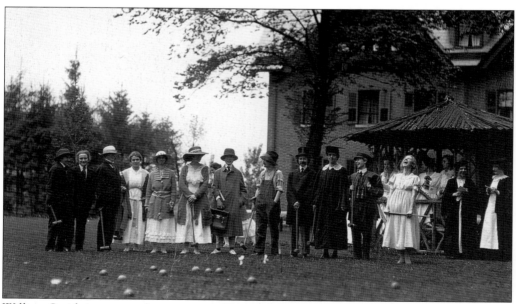

William Smith is very much a separate college with its own traditions; Class Day is one of them. In 1917, the senior class presented a parody of *Alice in Wonderland*. Alice (laughing, with a croquet mallet) was played by Marjorie MacDill; the Hare (in the top hat) was Ruth Smith.

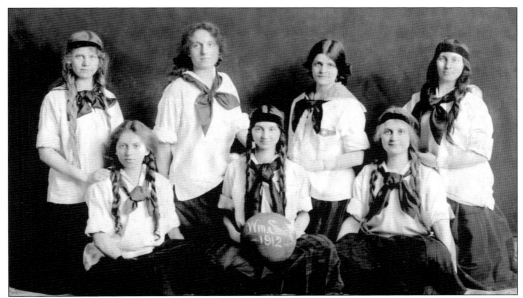

From the beginning, sports have been an important part of William Smith College. Class squads competed against each other in a number of sports. This was the basketball team for the Class of 1912, the college's first graduating class. (Courtesy of Hobart & William Smith Colleges Archives.)

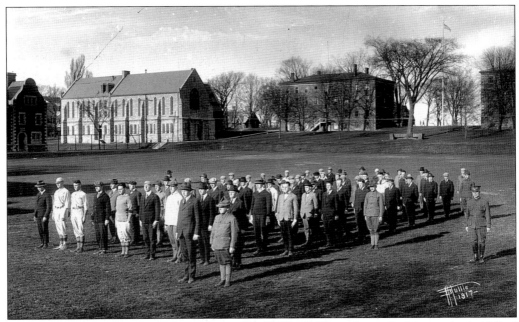

Hobart was hit hard by the U.S. entry into World War I. The military draft began in the fall of 1917; by May 1918, there were only one or two seniors left, and commencement was not held that year. On October 1, 1918, the campus became a government training facility for the Students' Army Training Corps. A total of 395 Hobart students and alumni served during the war.

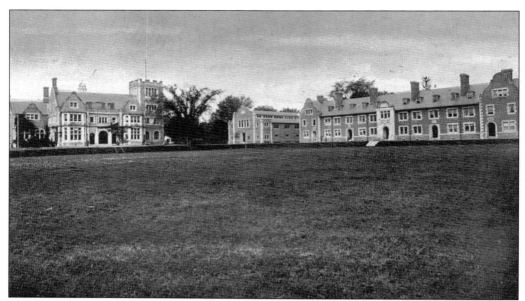

Hobart extended its campus to Pulteney Street in 1900 with the construction of Coxe Hall (left) and created a defined quadrangle by building Williams Hall (center) in 1907 and Medberry Hall (right) in 1901. The Jacobean-style brick buildings were a departure from the Gothic stone architecture that dominated the college.

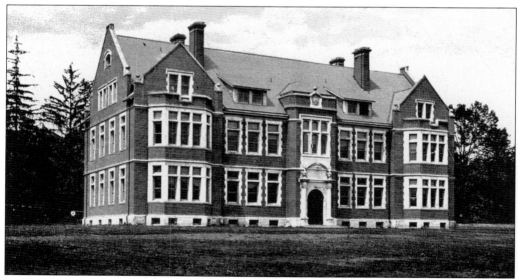

Smith Hall, the first building constructed from William Smith's endowment, was home to biology and psychology classes. Although Smith Hall was built on "the Hill"—the geographic separation of Hobart and William Smith's identities—both colleges used it.

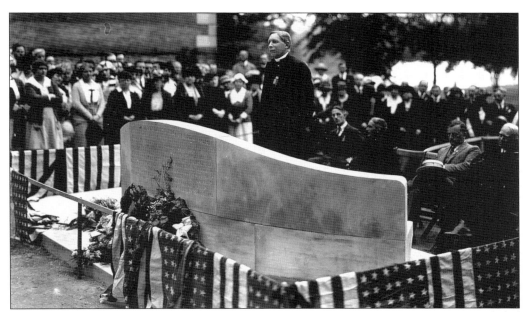

Hobart celebrated its first 100 years with Centennial Day on June 13, 1922. Festivities included the dedication of a servicemen's memorial bench between Trinity and Geneva Halls. Episcopal Bishop Charles Henry Brent, a World War I veteran, is shown speaking at the ceremony. The names of Hobart graduates and students who died in service are inscribed on the South Main Street side, and a curved bench faces the quadrangle.

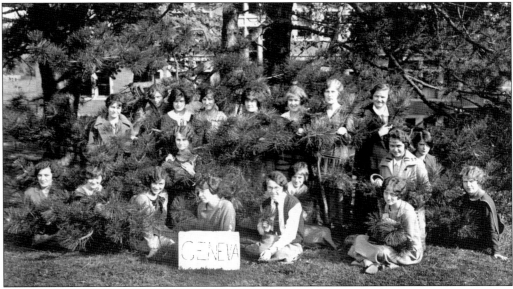

This 1925 photograph shows Geneva young women attending William Smith. From left to right are the following: (front row) two unidentified girls, Rosalyn Creedon '27, Edna Parker '27, Eleanor Graves '27, Hilda Manley '27, Florence Herman '25, and unidentified; (middle row) Irene David '27, Louise Klopfer '28, and unidentified; (back row) three unidentified girls, Ruth Hoster '27, Hester Brennan '26, Una Trautman '27, Gertrude Fuller '27, and Irene Graves '28. (Courtesy of Hobart & William Smith Colleges Archives.)

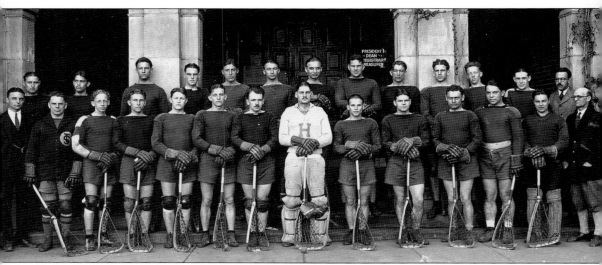

Hobart's illustrious lacrosse history began in 1898, when Dr. Joseph Leighton formed the first team. The first winning season was 1902, and by 1906, Hobart was a charter member of the U.S. Intercollegiate Lacrosse League. In the early years, Hobart regularly played against much larger universities—Harvard, Yale, and Cornell—as well as prestigious Native American teams. Five Statesmen have been inducted into the Lacrosse Hall of Fame. This 1924 team included the All-American goalie Henry Wheat (center, in white sweater) and longtime coach Dr. Jay Covert (far right in front row). There is a small "Beat Syracuse" sign on the door behind the back row; some things never change.

Five

IN GOD
WE TRUST

Any view of Geneva, past or present, features numerous church spires rising above the town. There has been a variety of denominations including some that are no more: Scotch Reformed, Dutch Reformed, and Universalist. Several denominations have had multiple congregations: Roman Catholic, Episcopalian, Presbyterian, and Baptist. In the 19th century, there were many local missions—mainstream denominations had chapels around town to minister to the poor, African Americans, and working class. Geneva is known for "de-spiring" its churches and using the buildings for many more years.

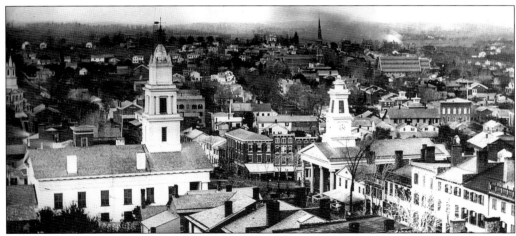

This aerial view, taken from the First Presbyterian Church *c.* 1875, shows many of Geneva's churches. From left to right are the Universalist church, Dutch Reformed church, Methodist Episcopal church, North Presbyterian Church (in background above the Methodist Episcopal church), and St. Peter's Episcopal Church, before the tower was added.

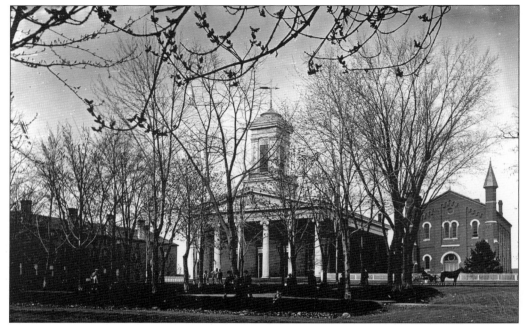

Incorporated in 1798, the Presbyterian Church is Geneva's oldest denomination. The first wooden building was erected in 1811 on Pulteney Park; this photograph shows the second church building, constructed in 1839 on the same site. The First Presbyterian Church was transformed to a Gothic appearance in 1877–1878, and its steeple was removed in 1950.

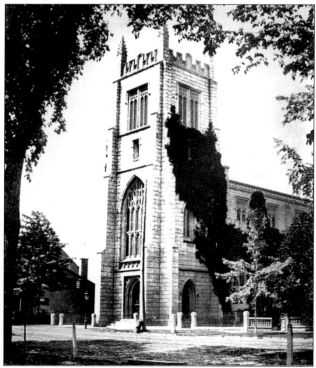

Trinity Episcopal Church was formed on August 18, 1806, by Episcopalian families formerly involved with the Presbyterian Church. The Rose and Nicholas families, who had moved up from Virginia, were among the church founders and exerted a strong southern influence. The first wooden church building was constructed in 1808; it was replaced by this Gothic stone structure in 1844.

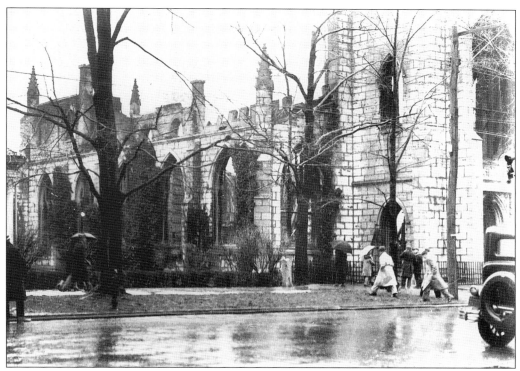

Trinity Church was gutted by fire on March 31, 1932, leaving only the limestone walls and tower. The congregation immediately began a campaign to rebuild, and Bishop Ferris rededicated the church on May 30, 1933. The original church design had been heavily borrowed from Richard Upjohn's Trinity Church in New York City. Hobart Upjohn, Richard's grandson, was commissioned to design the 1932 building and quipped, "Finally, my grandfather is getting paid his commission for this church in Geneva."

Methodism came to Geneva in 1793 in the form of circuit-riding preachers; the first regular meeting was established in 1818. The second Methodist Episcopal building is shown here, constructed in 1840 (the first church was built on Castle Street in 1821). When the congregation moved into its new church across the street in 1914, this structure was "de-spired." It has since been used as Adams Garage, the USO, and Geneva's Civic Center.

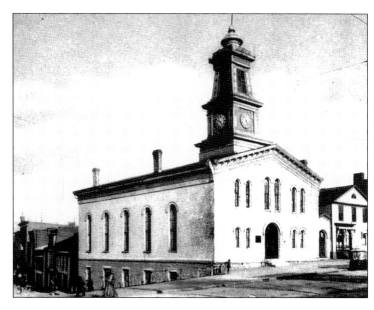

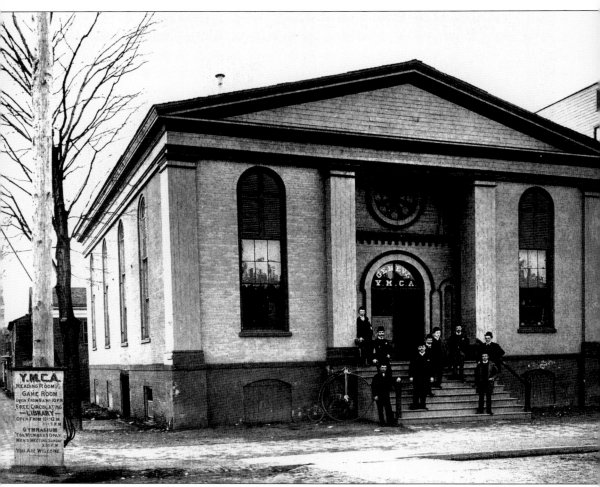

The Associate Reformed Church, also known as the Scotch Reformed Church, originated in Geneva in 1825. Its founding members belonged to Seneca No. 9 Associate Reformed Church but had tired of the long journey to worship. This church was erected in 1830–1831 on the corner of Castle and Genesee Streets. The congregation adopted the name United Presbyterian Church at Geneva in 1860. The building became Geneva's first YMCA in 1886. In 1876, some 120 young men of various denominations met to form the Young Men's Christian Union. The YMCU reorganized and joined the YMCA in 1886. This building was razed in the 1890s to make room for a new, more elaborate building.

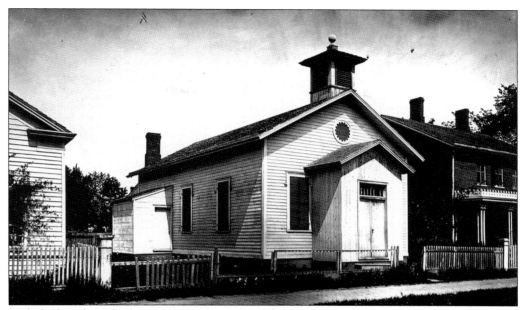

Bethel Chapel was built in 1850 on the west side of Exchange Street just north of Lewis Street. The Bethel Society, established in Geneva *c*. 1840, ministered to "neglected children" of the town's north end and children who traveled on the canal boats. The Bethel Chapel merged with the United Presbyterian Church in 1870, becoming the Second Presbyterian Church.

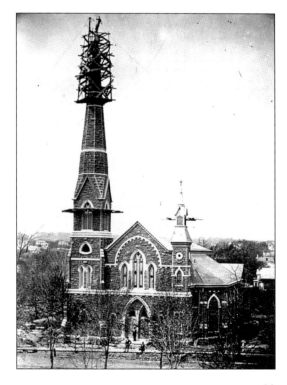

The Second Presbyterian Church was renamed North Presbyterian Church in 1874, and the limestone church on the northwest corner of Genesee and Lewis Streets was dedicated on July 6, 1876. Nurserymen Thompson, Joshua, and Henry Maxwell were principal benefactors in the construction. The two Presbyterian congregations began discussing a merger in 1953; 35 years later the Presbyterian Church in Geneva was formed. The North Presbyterian building is now occupied by Faith Community Church.

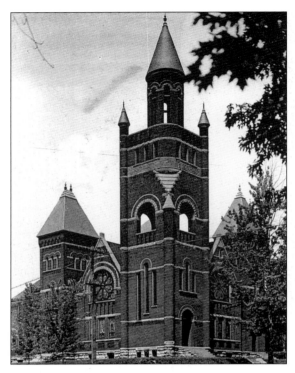

The First Baptist Society in Geneva was chartered in 1825. Its first church, built in 1829, was on Milton Street. Contractor William Dove built this North Main Street church for the congregation in 1894. The upper spire was removed after being struck by lightning. One of many Geneva churches to appear on the National Register of Historic Places, this one was added in 2002.

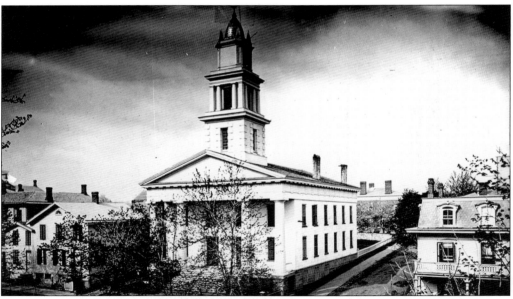

The Reformed Protestant Dutch Church was organized on August 24, 1831, under the Reverend Van Gelder. A blend of Dutch heritage, "Presbyterian government, and Calvinistic theology," the congregation met in various buildings until January 17, 1833, when this church was finished. The Dutch Reformed congregation lasted about 60 years. From 1904 to 1912, it was St. Stephen's Roman Catholic Church; later, it was a Masonic Lodge until the 1980s; it is now South Main Manor apartments.

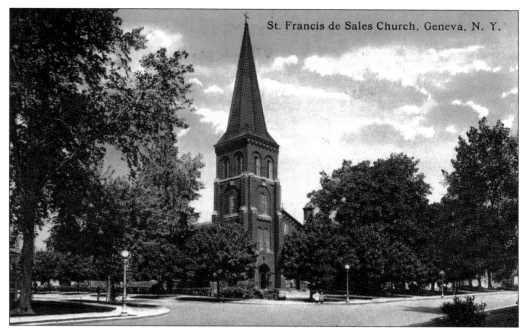

St. Francis de Sales Church, Geneva, N. Y.

The cornerstone for St. Francis DeSales Roman Catholic Church was laid in 1832. The first structure was greatly expanded in 1864–1867. Aside from smaller additions over the years, the exterior of the building has not changed. This original interior fell victim to an arsonist in the 1950s. A parochial school was started in the basement in 1853. A new school building was erected on the property in 1874.

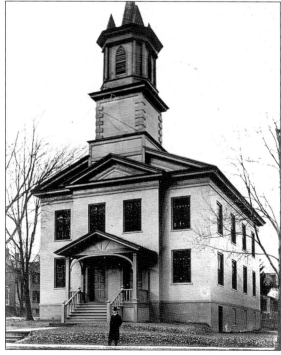

The Universalist Church was organized in November 1834. The congregation built a church the following year on the northwest corner of Main and Castle Streets. The congregation disbanded in 1910, and the Geneva Free Library moved into the building. The library has expanded, but the reading room, in the original portion of the building, retains the look of the sanctuary. Today, the spire and porch are gone.

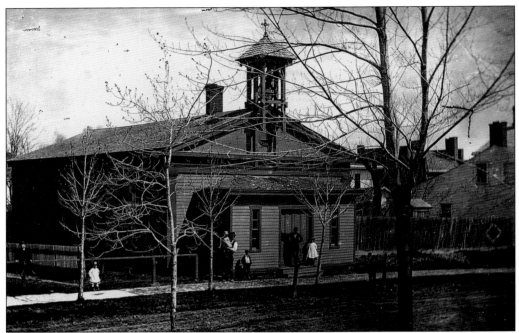

This Episcopal chapel on Genesee Street was originally used by the First Congregational Church, until *c.* 1850. The Right Reverend Bishop William DeLancey, the first Episcopal bishop of the Diocese of Western New York, acquired the chapel in 1853 and renamed it St. Peter's. This *c.* 1868 photograph shows the bell cote and porch addition, designed by architect Richard Upjohn in 1858.

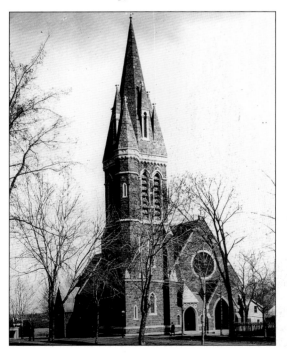

St. Peter's Episcopal Church, a memorial to Bishop William DeLancey, was completed in 1870. Consecration ceremonies lasted a week, and 3,000 people came to Geneva for the occasion. The building's architect was Richard Upjohn (1802–1878). By 1878, enough money had been raised for the bell tower, and Upjohn's son, Richard Michell Upjohn (1828–1903), designed it.

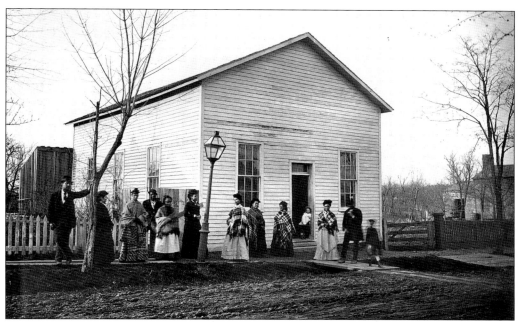

Built *c*. 1834, this chapel was used until *c*. 1891 by the Union Religious Society of Colored People when a new chapel was built at the corner of High and Grove Streets. It was also used as the High Street Sabbath School. Separate churches formed in part because African Americans were tired of their treatment at white churches: separate pews, separate communion, and weak or no church opposition to slavery.

The Evangelical denomination began as a German-speaking ministry of the Methodist faith; later, it became autonomous. Gustav Wilkins and Henry Schroeder invited the Reverend Reuber to Geneva in 1872 to preach to German residents. The First Evangelical Church was organized in 1874; the congregation built this church on North Main Street in 1885. The Evangelicals merged with the United Brethren *c*. 1942, and became part of the United Methodist Church in 1968. The Southern Baptists moved into this building in 1968.

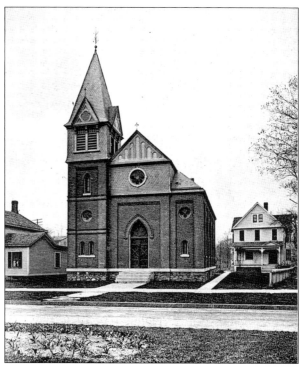

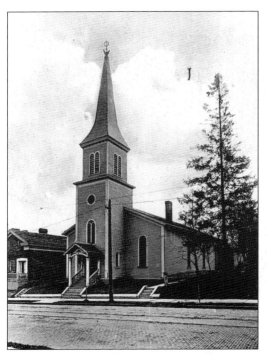

This building, at 21 Milton Street, is a classic Geneva story of church swapping. Built by the Baptists in 1829, the Lutheran congregation purchased it in 1899 shortly after the arrival of the first resident minister, Pastor Martin F.G. Toewe. The Zion Lutheran Church erected a new church on Snell Road in 1975, and this building is now the Mount Calvary Church of God in Christ.

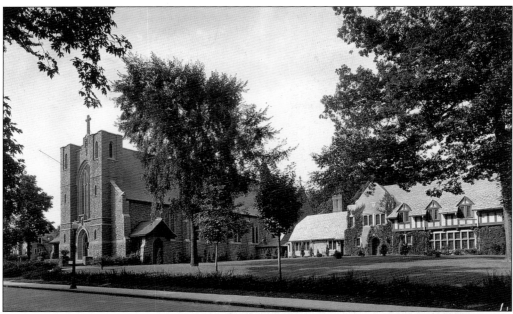

The Catholic community grew large enough to necessitate creating a second parish in 1904. St. Stephen's served the city south of Castle Street and west of Main Street. The new congregation purchased the old Dutch Reformed church in 1904. Services were held there until 1912, when the congregation moved to this building at the corner of Pulteney and High Streets. St. Stephen's Parochial School met in the basement of the old church until the new school was completed in 1917.

This was the first home of the Salvation Army, at 387 Exchange Street. It was the former hose house for the Nester Hose Company fire department. The city directory shows that the Salvation Army, located here in 1897, moved to 431 Exchange in 1899, to 424 Exchange in 1905, and to 41 North Street in 1977. From left to right are Amos Fleming, three members of the Salvation Army Corps, an unidentified child, James Catchpole, and ? Burgess.

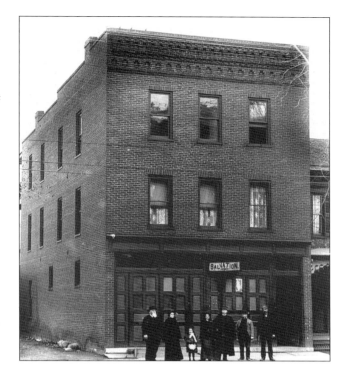

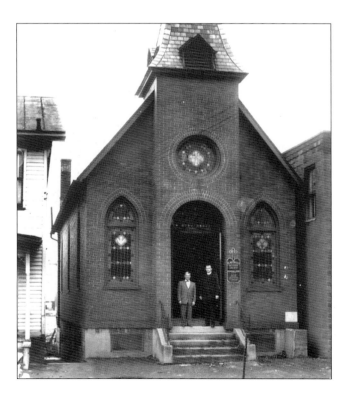

By the start of the 20th century, Geneva had a sizable Syrian community. Recalling the words of loved ones left behind in Syria, "Seek God first and prepare to build a temple unto His holy name," a group of parishioners built this church in 1915. St. Michael's Syrian-Greek Orthodox Church was constructed on Geneva Street by the congregation's own labor. In 1961, the parish moved to a new church at 98 Genesee Street.

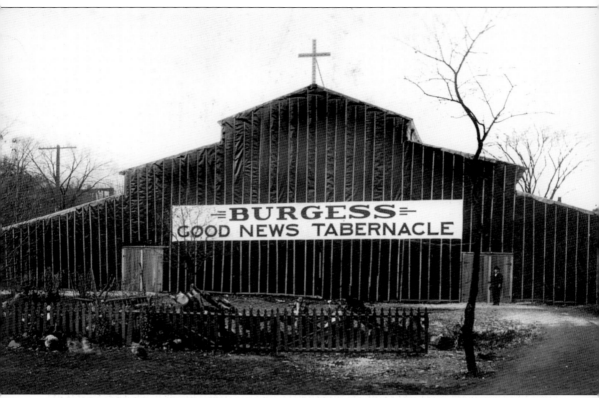

This large warehouse stood for approximately 10 years at 164 North Main Street, adjacent to the German Evangelical church. City directories from 1922 to 1932 show the building as being vacant, used for storage, or occupied by Geneva Auto Company. Little is known about its use as a tabernacle other than a newspaper index of March 26, 1933, which states, "The tabernacle at the rear of the John T. Lynch home was being torn down." It is interesting that, by 1920, there were 18 churches and chapels in Geneva, about the same number that exist today.

Six

SENECA LAKE

The Finger Lakes were created by glacial action over a million years ago. As a result these lakes flow north. Seneca Lake is the deepest of the 11 lakes and the deepest lake east of the Mississippi, at 634 feet. The head of the lake is 36 miles to the south at Watkins Glen. A connection to the Erie Canal made the lake a major transportation artery. Lake property had little value during most of the 19th century, but it is the most desirable and expensive type of real estate today.

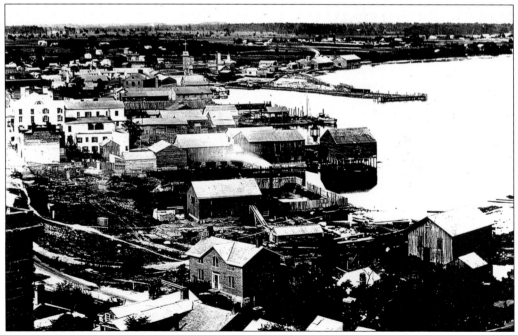

Taken at the time of Geneva's industrial boom, this photograph shows Samuel Nester's main malt house and the adjacent lumber holding bay and planing mill of John Mackay and Genet Conger. Ever-changing clusters of canal barges—loading and unloading, and moored for the night—were a constant presence in the harbor. It is interesting to compare this photograph with the one on page 54.

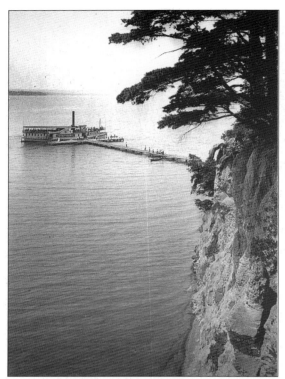

The east side of Seneca Lake is studded with high cliffs, creating beautiful views of the lake. The *Otetiani* is exchanging passengers at one of the many regular stops along the lake. Cottagers set their clocks by the sound of the approaching steamboat. One could leave Geneva at 8:15 a.m. and arrive at Watkins Glen by 12:15 p.m. The *Otetiani*, built in 1883 by William B. Dunning, sank in 1909.

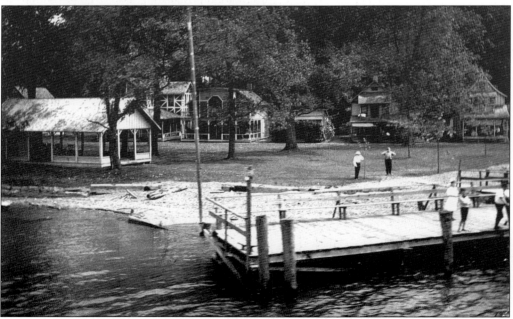

This 1906 photograph shows the Hiawatha Inn, at Glen Eldridge Point on the southeast side of the lake near Watkins Glen. There are more than a dozen such points around the lake. During the late 19th century and early 20th century, lakeside resorts were popular recreation spots. Steamboats were the main public transportation to these points and the lakeside hotels.

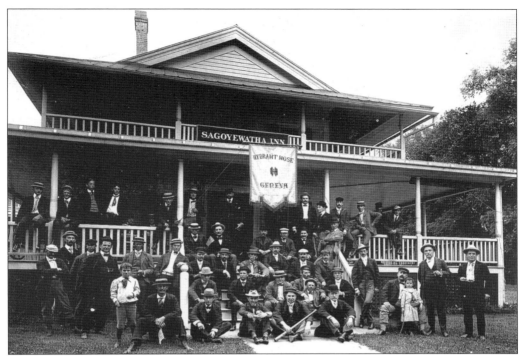

The Sagoyewatha Inn, built c. 1900 by Elmira investors, burned to the ground in 1910. North Hector Point was a very popular steamboat destination for dancing, lawn games, fishing, and sailing. Here, in 1899, Arthur E. Valois, a New York City lawyer, enlarged a cottage into a castle. For whatever reason, the point was renamed Valois in 1903.

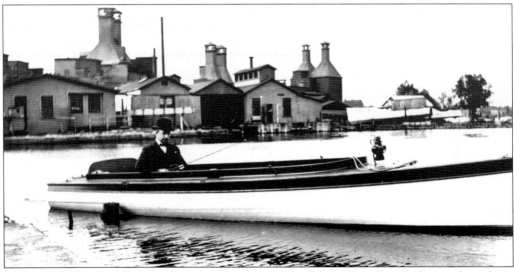

Herbert McGuril is all dressed up to do some serious fishing in a Fay & Bowen launch. Is he posing, or does he really wear a bow tie and bowler hat to stalk the wily Seneca Lake trout? McGuril was a molder at the Summit Foundry. This May 30, 1916 photograph shows the northwest end of the lake. The Nester Malt House (background) disappeared from the lakescape in the 1920s.

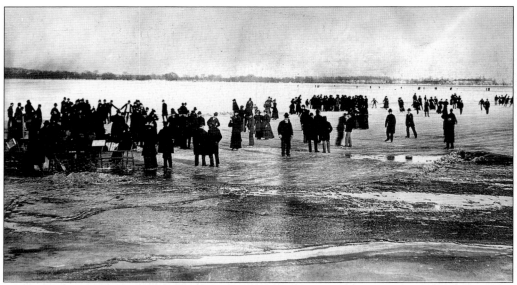

Because of its depth, Seneca Lake has only frozen from end to end four times in the history of the white settlement: 1855, 1875, 1885, and 1912. The shallower Geneva end freezes more often. Before refrigeration, blocks of ice were cut from the lake and stored in an icehouse. This photograph was probably taken in 1912. People knew the importance of skating with a tie or hat.

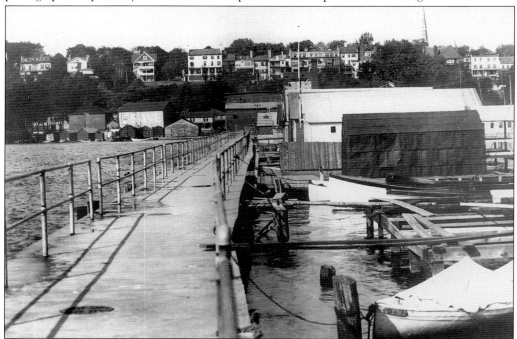

The first section of Long Pier was built in 1828 for harbor protection. This 1909 photograph, looking west, shows an extended pier and a few boathouses. Eventually, the north side of the pier was completely lined with boathouses. An arterial highway severed the pier from the city in the 1950s. In 1962, the state burned the boathouses. In 2001, the pier was completely rebuilt as part of the lakefront park.

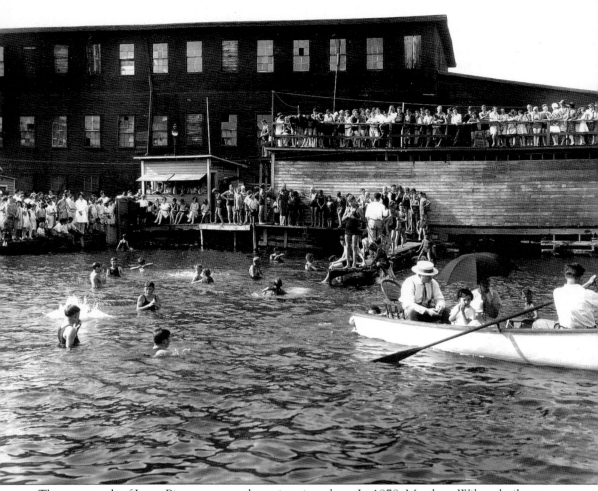

The area south of Long Pier was a popular swimming place. In 1878, Matthew Wilson built two bathhouses near the pier—one for older boys and the other for younger ones. At that time it must not have been proper for girls to swim. Charles Green developed a commercial recreation area here in 1916. Green's Pavilion had a wooden water slide into the lake, a diving tower, and a concession stand. This photograph was probably taken in the 1920s, when Green's hosted an annual Aquatic Carnival that included a "Lighthouse-to-Green's boathouse swim," 50-yard and 100-yard dashes, a swimming relay, and a diving competition. There is a lot happening in this picture: notice the man in the boat, with the bentwood chair, straw hat, and tie. Business at Green's waned in the 1930s, possibly due to the development of a municipal beach or from concerns about pollution from the nearby U.S. Radiator plant.

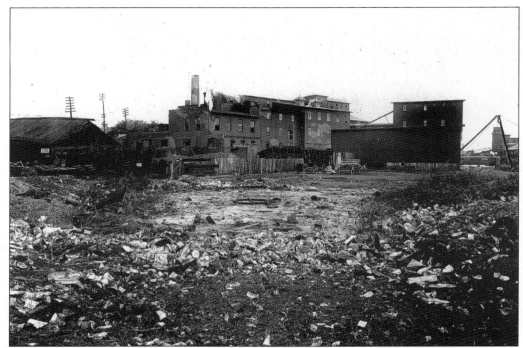

This scene along the lakefront north of Castle Street and south of Patent Cereals *c.* 1905 would horrify any chamber of commerce president. In 1900, the canal towpath was extended from Lake Street south to the Long Pier, cutting off these buildings from the lake. The towpath project did not include the filling in of the former lakeshore, thus creating a large stagnant pond suitable for the dumping of trash.

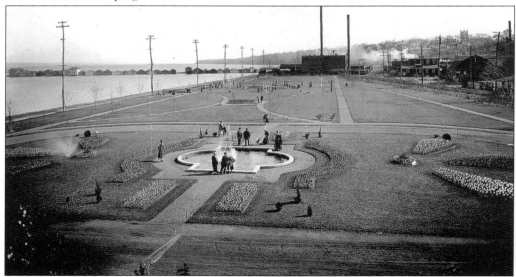

A 1905 Park Act granted all the fill land "formerly under the waters of Seneca Lake" to the city, along with permission to acquire rights from "abutting property owners" to create a park. Those property owners fought the law in court for seven years. The park finally opened in 1916. This view is looking south toward Long Pier. Lakeside Park became a parking lot in the 1950s.

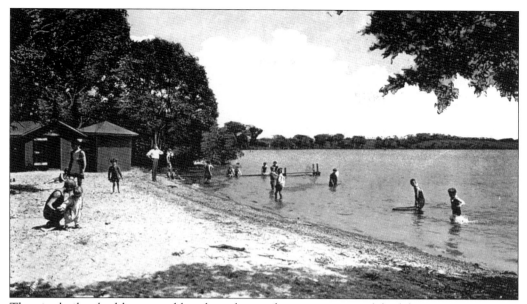

The city built a bathhouse and beach at the northeastern corner of the lake in 1910. In 1929, the city purchased land all the way to the outlet and created a municipal bathing beach. This area became Seneca Lake Park. This view is from the 1930s. In the 1950s, some 5,000 people would often visit Seneca Lake Beach in a day. The area became a state park in the 1960s.

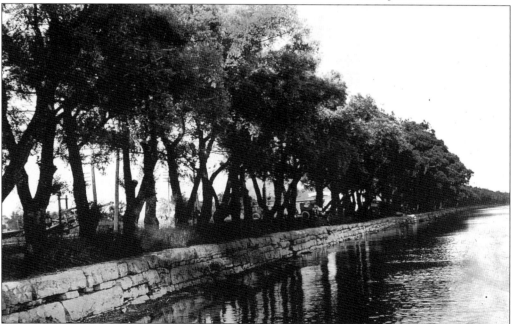

"The Willows," trees in a grove along the lake, date to the 1890s. This 1920s view shows additional trees that were planted by the American Legion to honor those who died in World War I. The limestone seawall was completed in the 1890s. The Lake Road was only 15 feet from the water. The road was moved in the 1960s, but the Willows are still a beloved feature of the lakeshore.

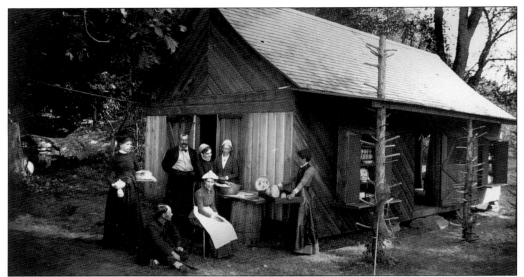

Fossenvue is an anagram of "seven of us." Elizabeth Smith Miller, Anne Fitzhugh Miller, Ruth Lesley VerPlanck, Emily Dilworth Snyder, Anne Palfrey Bridge, James Fowler, and William Fitzhugh Miller embarked on a camping adventure in July 1875. The campsite Fossenvue began with tents and gradually added buildings. The group of seven used the campsite at Fassett's Point, on the lake's southeast side, into the 1900s.

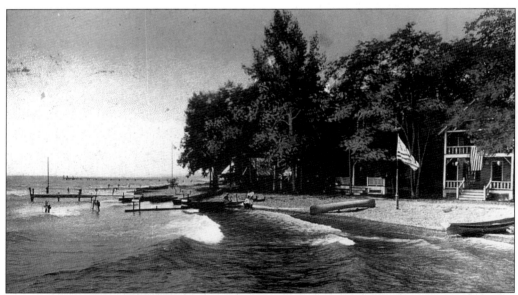

Some five miles from Geneva on the lake's west side is Kashong Point. Native Americans occupied it until the late 18th century. At the end of the 19th century, Kashong had a steamboat landing, a beach, and two hotels. Cottages appeared c. 1900. The Tribe of Kashong was formed in 1912 to govern the settlement. The settlers have held a special ritual celebration every Labor Day since 1926.

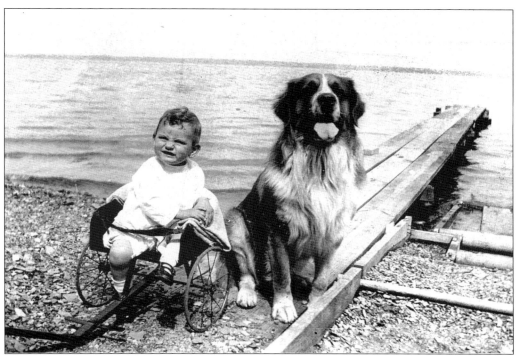

What more could one want than a baby, a dog, and the lake? This photograph was taken at Kashong in 1920. The baby is H. Edmond Wirtz (1918–1991).

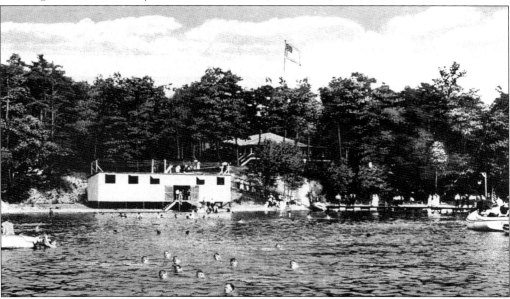

To attract more passengers for his boat, the *Portadora*, Capt. Frank Tower developed Pastime Park in 1914 on the northeast side of the lake. He built a 50-foot by 100-foot pavilion for dancing and entertainment. The park included a bathhouse, tennis courts, and picnic grove. It became an attractive spot for Genevans to build cottages—businessmen could summer with their families, taking the *Portadora* to and from work each day.

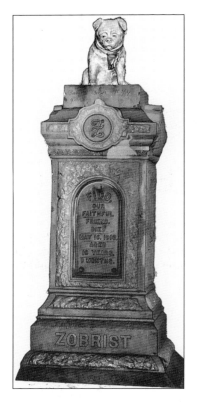

Fido, the pug dog, belonged to Henry Zobrist, a local druggist. Zobrist created a monument to Fido after the dog's death in 1913. The monument first stood at the Zobrist home, on Elm Street, and then in a pet cemetery by the lake, before finding its way here, to the Pastime Park entrance. The oft-decorated and once stolen statue makes it a snap to find the Pastime Park cottages from the East Lake Road.

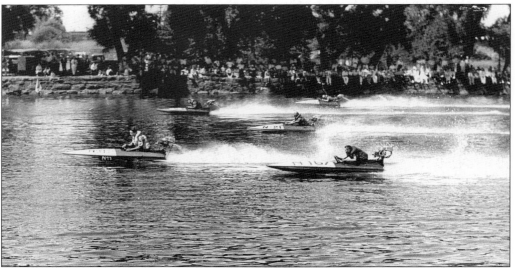

Boat racing became a popular sport in the 1920s. This July 1939 photograph shows "outboard" motorboats, "coming down the straightaway," competing for the New York State Outboard Championship. This occasion was Geneva's 12th annual Power Boat Regatta. Boat races ceased in the 1940s, but hydroplane races started in the 1950s. There have been no organized races here since the 1960s, when promoters determined that Seneca Lake was too unpredictable for high-speed racing.

Seven

TO PROTECT
AND SERVE

Geneva's safety and well-being have been ensured by a long line of public servants. Many of these have been volunteers or have provided service far beyond the pay they received. The photographs of everyone who has worked in public safety, government, or healthcare would fill several books; this chapter honors all those who have served.

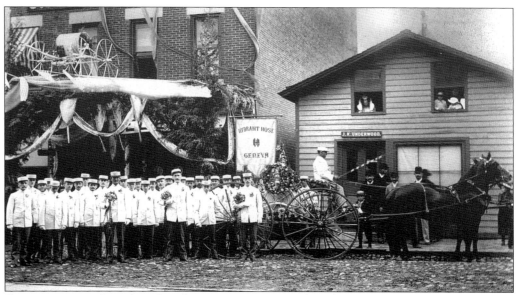

Geneva organized its first fire department in 1816; that department and subsequent ones operated as volunteer companies until 1870. Paid firefighters were used for 10 years until the citizenry petitioned village trustees for a return to volunteer companies. Hydrant Hose Company was the first company to be founded in 1880. Members of that company are shown on Linden Street with their first building, on the left (the site of the current the post office). J.K. Underwood's jewelry shop is behind them.

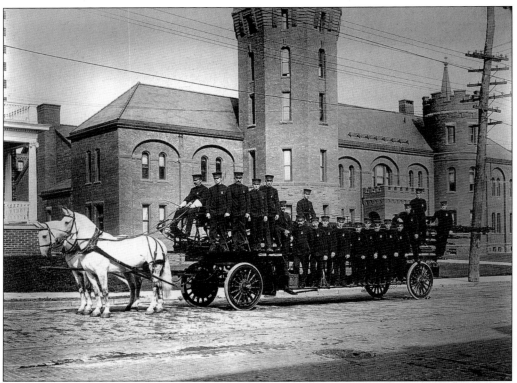

The Folger Hook & Ladder Company, formed on February 19, 1886, was the city's third fire company; Nester Hose Company was approved two days earlier. The hook and ladder company was named in honor of Charles J. Folger, former Geneva fireman and secretary of the U.S. Treasury who died in 1884. This photograph was taken in front of the Armory in 1910.

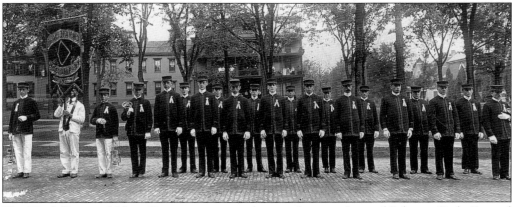

The Black Diamond Hose Company poses in dress uniforms in front of Pulteney Park. Formed in 1896 to serve the Torrey Park neighborhood, the hose company was named after a Lehigh Valley Railroad express train. The company disbanded in 1912.

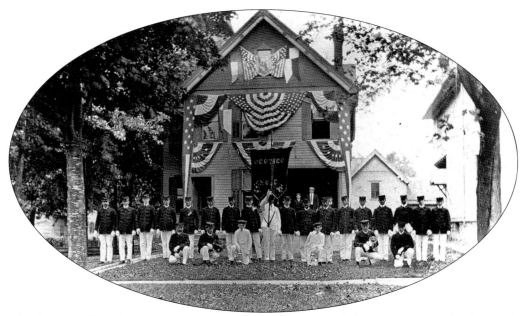

The Ogoyago Hose Company was organized *c.* 1884 to provide better protection for the south side of Geneva. The company raised enough money to build this firehouse in 1889 on the northeast corner of Pulteney and Hamilton Streets. Ogoyago dissolved in 1907.

The New York State Armory was built in 1891–1892 as a permanent home for the National Guard, which had been meeting in Dove's Hall. This was the original building; an office wing was added in 1906, the conical roof was replaced with a crenellated tower in 1916, and an entry porch was built in 1917.

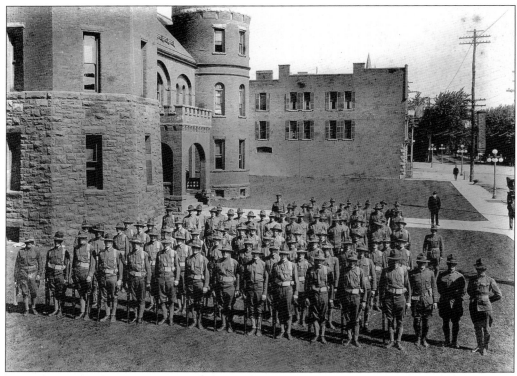

Formed in 1879, Company B mustered as 34th Separate Company in 1880. It bore the "civic" name of Folger Corps. Shown in front of the Armory in 1919, Company B was called up for the Spanish-American War in 1898, for duty along the Mexican Border in 1916, and for the preservation of peace during labor strikes in Buffalo in 1892 and 1913.

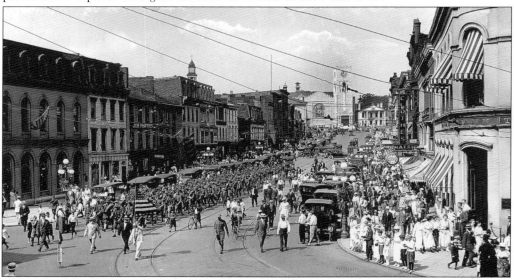

Company B marched off to war on August 16, 1917. The men spent much time training stateside before going to Europe and made an impression once they arrived. Company B was involved in the 1918 charge on the Hindenburg Line as part of the 27th Division, 108th Regiment.

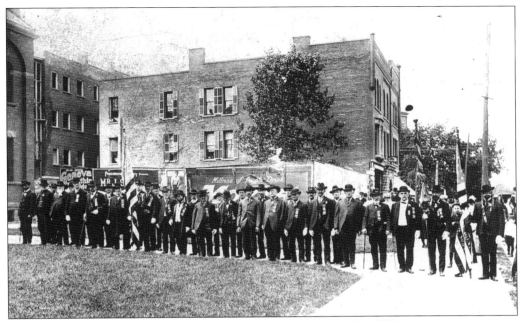

The Grand Army of the Republic (GAR) was the Union Army's Civil War veterans association. The group held annual reunions as long as its members drew breath. This gathering was held c. 1909 in front of the New York State Armory; almost 45 years after the end of the war, there was still a sizable crowd of veterans.

During much of the 19th century, Geneva provided for the safety of its residents with a system of night watchmen and village constables, and support from the county sheriff. The first village lockup was in Union Alley; the second jail, shown here, was behind the village hall on Seneca Street from 1860 to 1913.

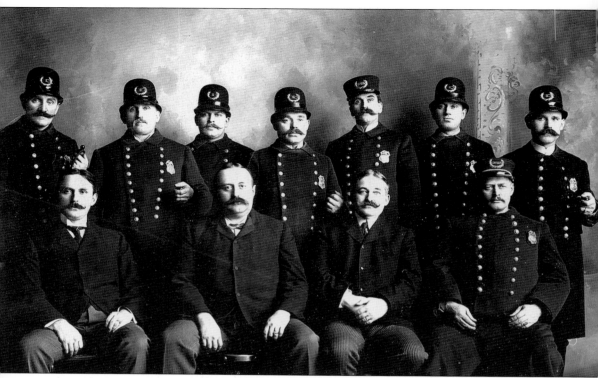

The police department was established on May 14, 1882, by an act of the New York State Legislature; four officers were on duty less than a month later. This photograph was probably taken *c.* 1900. From left to right are the following: (front row) three unidentified men and Chief Daniel Kane; (back row) Elmer Merry, Lawrence Kinney, William Kuney, Aeneas McDonnell, Capt. William Beals, unidentified, and Daniel Hawkins. Thankfully, Aeneas McDonnell is the only Geneva police officer killed in the line of duty. McDonnell (often misspelled as McDonald) was shot by Howard Keavin on the morning of February 19, 1924, during a chase; Keavin and his brother-in-law Edward Doyle had attempted to rob the safe at the New York Central Railroad station.

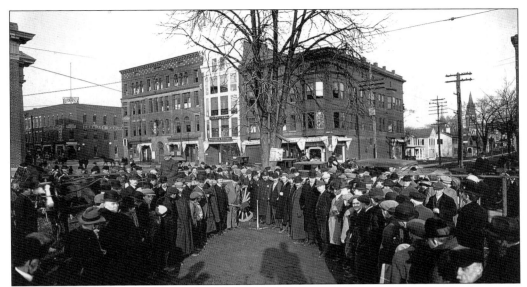

Geneva City Hall was built on Castle Street in 1913. The upper photograph shows the groundbreaking on January 1, with Mayor Reuben Gulvin wielding the shovel; the Centennial Block and YMCA are visible in the background. The lower view was taken in October when the building was about three-quarters complete. Visible in the rear is the attached firehouse, which housed the equipment for Folger Hook & Ladder Company and Nester Hose Company.

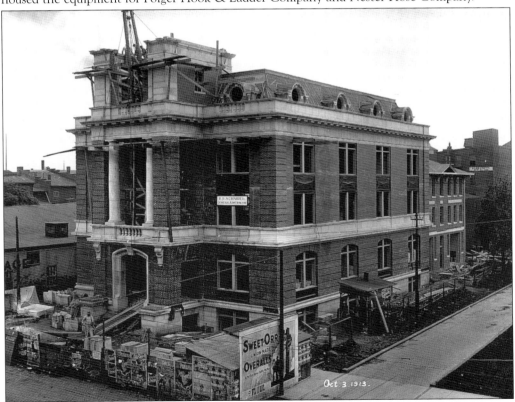

Geneva Medical and Surgical Hospital opened in 1898; the name quickly changed to Geneva City Hospital later that year. The original hospital consisted of the center portion and the one-story east wing on the right. The west wing was added in 1903, and this photograph dates to that period, before another story was added to the east wing. The hospital's name changed to Geneva General Hospital in 1925.

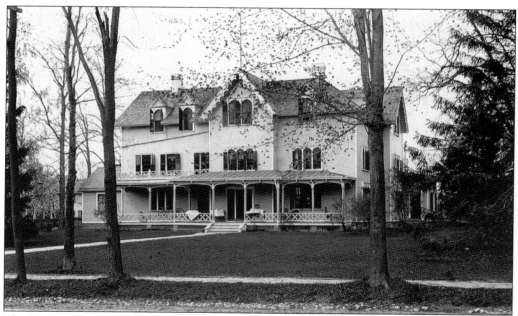

The Foster Swift Foundation established the Church Home of Geneva, on the corner of Pulteney and High Streets. The Church Home was incorporated on April 27, 1878, and the property was purchased a short time later. The Church Home moved to 600 Castle Street *c.* 1923; DeSales High School is now on this site.

Eight

DIVERSE GROUPS AND OUTSTANDING INDIVIDUALS

Geneva has an ethnic diversity unusual for a city of its size in the Finger Lakes region. Some immigrants came more willingly than others, some were more welcome than others, but all made an impact on Geneva. Although all Genevans have contributed to the city's personality and achievements, some have become noteworthy on a national and worldwide scale.

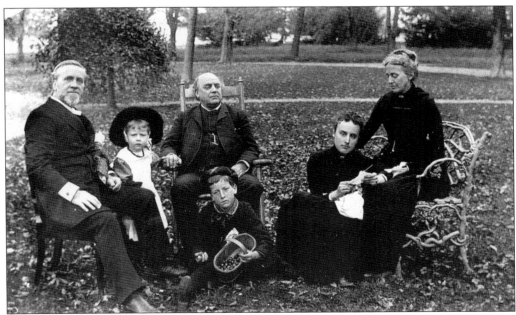

Robert Swan (1826–1890) received the Rose Hill mansion and farm as a wedding present in 1850. Swan advocated modern farming techniques, winning the 1858 award for best farm from the New York State Agricultural Society. He was a leader in the effort to create the Agricultural Experiment Station in Geneva. From left to right are Dr. James L. Robertson, unidentified, Robert Swan, unidentified, Agnes Swan, and Maggie Robertson.

Syrian immigrants began arriving in Geneva c. 1895 and settled in the neighborhood of Geneva, Tillman, and Exchange Streets. The Abraham family started George's Candy Kitchen, at 364 Exchange Street, c. 1913. It was a family-owned business for many years; Joseph and daughter Ethel are shown making Easter chocolates in 1946.

Raymond DelPapa (1858–1947) was born in Carunchio, Italy. He immigrated to Geneva in 1893 by way of Elmira. He filled an important role as overall service provider to Italian immigrants. His enterprises included rental properties, a private bank, saloon, grocery store, bakery, a steamship agency, and an employment agency furnishing men for construction jobs. DelPapa is shown surrounded by children and grandchildren on the occasion of his 85th birthday in 1943.

John, William, and Jeremiah O'Malley constructed this building in 1895 at 398 Exchange Street for their business. J. O'Malley & Brothers sold everything from groceries and "fancy goods" to steamship tickets. By 1895, there were a good number of Irish-Americans in Geneva; many were working-class families, but there were several business owners and professionals.

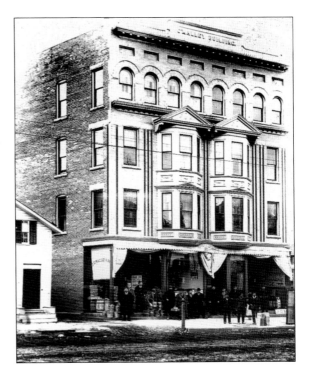

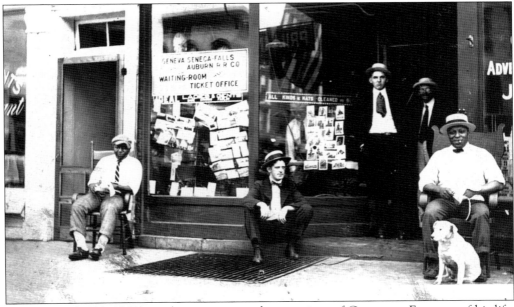

Art Kenney (1880–1968) was known to several generations of Genevans. For most of his life, he operated a shoeshine business, first, at 19 Seneca Street and, later, on South Exchange Street. A fixture at Hobart athletic events, Kenney (right) befriended many students. With him in front of his Seneca Street shop, from left to right, are Charles Whitaker, "Quigley the barber," George O'Malley, and ? Kennedy.

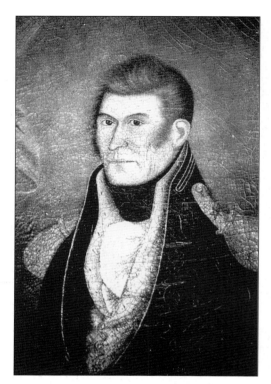

Hugh Dobbin (1767–1855) was a veteran of two wars, serving in both the American Revolution and the War of 1812. Dobbin was lieutenant colonel of the 102nd Infantry Regiment, New York Militia, during the War of 1812; he was promoted to brigadier general of the 38th Infantry Brigade in 1816. Although Dobbin lived north of Geneva, he was a founder of the local Universalist Church and an ancestor of many a Dobbin in Geneva.

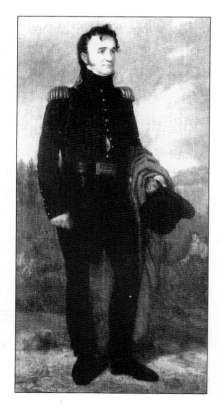

Gen. Joseph Swift (1783–1865) was the first graduate of West Point, in 1802. His claim to fame was as an engineer more than as a soldier. During the War of 1812, he designed defenses along the St. Lawrence River and in the New York City harbor, and he served as chief engineer of the United States from 1812 to 1818. Swift moved to Geneva in 1829; he is buried in Washington Street Cemetery.

Elizabeth Stryker Ricord (1788–1865) valued intellectual activity for women. In addition to operating the Geneva Female Seminary from 1829 to 1842, she is credited with the first textbook of psychology, or "mental philosophy," written by a woman for women students. Published in 1840, *Elements of the Philosophy of Mind, Applied to the Development of Thought and Feeling* was based on her lecture notes that she used at her school.

John Johnston (1791–1880), a Scottish immigrant to Seneca County, is considered "the Father of Tile Drainage in America." Drainage was an old concept, but Johnston promoted it tirelessly in lectures and in practice. Johnston had thousands of clay tiles produced in Waterloo and created miles of drains on his 320-acre farm. Neighbors who mocked him for "burying crockery in the ground" were amazed when Johnston tripled the yield of his wheat crop.

Charles J. Folger (1818–1884) moved to Geneva with his family in 1830. Folger studied law after graduating from Hobart College in 1836. He returned to Geneva in 1840 and established himself as a judge and political figure. He rose to chief justice of the New York State Court of Appeals in 1880 and turned down Pres. James Garfield's invitation to become U.S. attorney general in 1881. Folger later accepted the post of U.S. secretary of the treasury under Pres. Chester A. Arthur and managed to reduce the public debt by $300 million. Folger died in Geneva on September 4, 1884; his funeral was attended by the president and most of his cabinet, Gov. Grover Cleveland, and four U.S. Supreme Court justices.

William Smith (1818–1912) left his native England in 1843 to follow two of his brothers to Geneva. After working for a local nursery, Smith, in 1845, convinced his brothers to purchase land on Castle Street, where they started W.T. & E. Smith Company in 1846. The nursery's success enabled Smith to indulge in philanthropy; he is seen here with the first graduating class of his greatest legacy, William Smith College.

Elizabeth Blackwell (1821–1910) came to Geneva Medical College in 1847 after 28 other schools refused her admittance. Some historians believe Geneva accepted her as a joke, but she graduated in 1849 as the first woman in the United States to receive a medical degree. She devoted her life to providing health care for poor women and children, and in 1868, she established the Women's Medical College of the New York Infirmary.

Elizabeth Smith Miller (1822–1911) was the daughter of abolitionist Gerrit Smith and the cousin of Elizabeth Cady Stanton. Shown on the porch of their home, Lochland, Miller and her daughter Anne (1856–1912) formed Geneva's Political Equality Club in 1897 to work for women's suffrage. Miller used her connections to attract statewide conventions and internationally known suffragettes to Geneva. Frederick Douglass, Susan B. Anthony, and Stanton were frequent houseguests at Lochland.

Dr. William R. Brooks (1844–1921) built his first telescope from farm machinery parts as a youth; his mechanical and scientific skills grew as he matured. Brooks discovered his first comet in 1881 while living in Phelps. William Smith built a house and an observatory for Brooks on Castle Street in 1888, where Brooks discovered 27 comets. Brooks also taught astronomy at Hobart College for many years until his death.

Like many children, William Hoefler (1872–1955) bypassed learning how to pedal a bicycle and immediately began doing stunts. At age 11, he was paid to perform bicycle tricks in Phelps; at age 17, he was recruited for the circus by Phineas T. Barnum. Hoefler performed around the world, doing tricks that included dismantling his bike while riding it and riding a wagon wheel down a tall ladder.

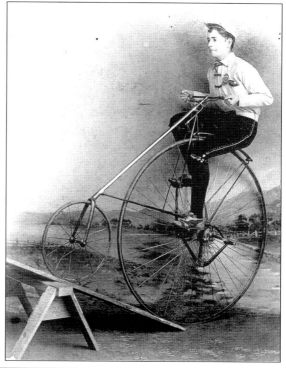

Marian Cruger Coffin (1876–1957) (left) came to Geneva at the age of seven with her mother. She left in 1901 to train at Massachusetts Institute of Technology. She then established a landscape architecture practice in New York City. Among the first women landscape architects, Coffin worked for some of the East Coast's wealthiest families, received the Gold Medal of the Architectural League of New York, and wrote *Trees and Shrubs for Landscape Effects*.

Arthur Garfield Dove (1880–1946) was America's first modernist painter. Dove grew up in Geneva and attended Hobart College and Cornell University before moving to New York City and becoming an illustrator. His fame lay in the abstract paintings he began creating in the second decade of the 1900s. Dove and his second wife, artist Helen "Reds" Torr, lived in Geneva from 1933 to 1938 and produced a number of paintings inspired by the city and Seneca Lake.

Henry McDonald (1891–1976) was a Geneva sports icon for decades. He coached DeSales High School football, served as a trainer for Hobart College, and umpired youth baseball games. His fame extended beyond Geneva. McDonald was one of the first African American professional football players, and played baseball professionally in the Negro National League. In 1973, he was inducted into the Black Athletes Hall of Fame, alongside Willie Mays and Jackie Robinson. (Courtesy of DeSales High School.)

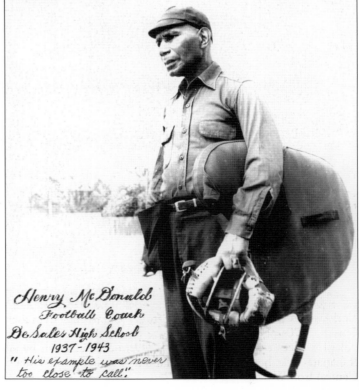

Henry McDonald
Football Coach
DeSales High School
1937–1943
" His example was never too close to call."

Nine

LEISURELY PASTIMES

The pace of life before 1940 seems to have been less hectic than it is today. People tended to be participants in activities, as well as spectators. Geneva's industries, fire departments, and fraternal organizations offered opportunities for sports and music. The lake and the city parks provided for a variety of leisure activities. Then as now, people spent their free time with family and friends.

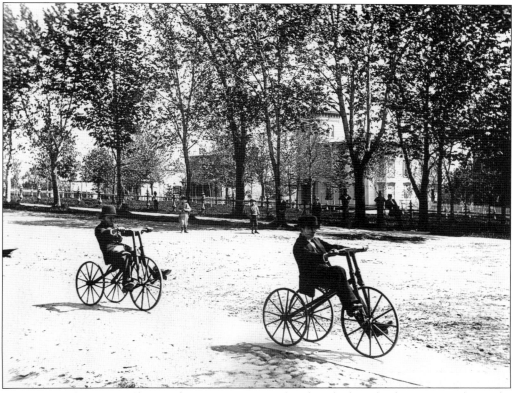

Nothing was better on a late-19th-century summer day than kicking back on your velocipede. This *c.* 1870s photograph of Genesee Street shows Genesee Park in the background. The village trustees created the park in 1849 from land given by adjacent property owners. The Italianate-style home in the background was built by William Dunning of the New York Central Iron Works.

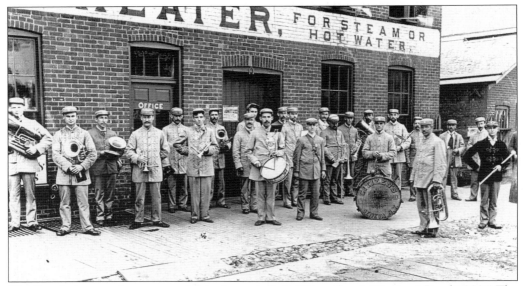

The inscription on the reverse of this photograph is "Herendeen's 'Pig Iron' Band 1900." The Citizen's Cornet Band—the official name on the bass drum—appears once in the Geneva city directory *c.* 1897. The director was C.A. Furman, who was also the foreman at Herendeen Manufacturing Company, the factory in the background. The company may have sponsored the band, leading to its foundry-related nickname.

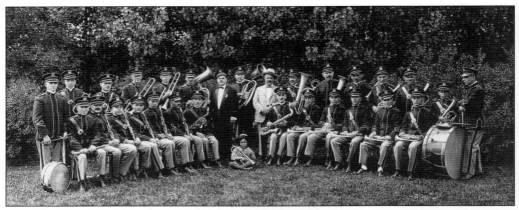

An Italian-American organization, the Italian Society of Victor Emmanuel III, was established in Geneva *c.* 1907. This may have been the society's brass band in the 1920s. The gentleman in the dark suit (center) was Nicholas Legnini, the conductor. Legnini was well known as a band man; the city directory listed him as "insurance salesman and band master."

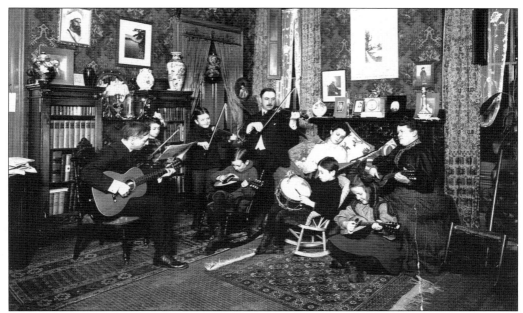

Hammond Tuttle was a local photographer who documented his family, in addition to his paid assignments. It is hard to say how staged this *c.* 1905 photograph is, but "Ham" Tuttle (far left, with guitar) played first guitar in the Geneva Mandolin Orchestra in the early 1890s. Playing music was a popular family pastime, and the ability to play an instrument was considered a mark of refinement. (Courtesy of Mr. and Mrs. Robert Lautenslager.)

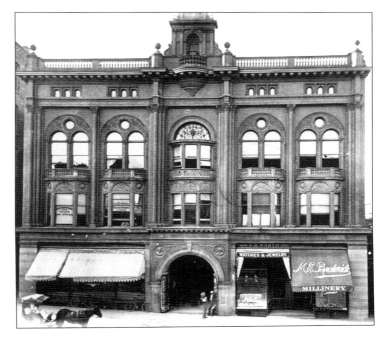

Nurseryman William Smith built the Smith Opera House in 1894 for Geneva's cultural benefit. The Smith offered drama, comedy, Shakespeare, music, and meeting space. Schine's Amusement Company bought it in 1927. After extensive renovations, Schine's Geneva Theater opened as a movie palace in 1931 and closed in 1978. It was saved from demolition by the Finger Lakes Regional Arts Council, which restored the building to its former grandeur.

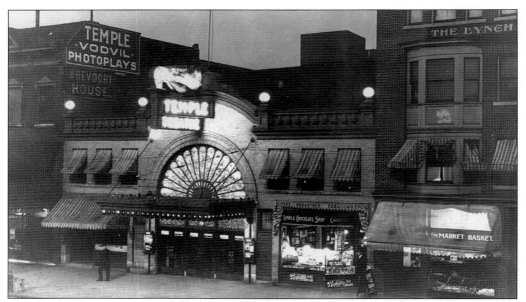

The Temple Theatre was at 413–417 Exchange Street, north of Castle Street. It opened in January 1912 as a 5¢ moving picture house with a stage for vaudeville. This night view was taken c. 1915. Closed during the Depression, the theater was reopened by the Schine chain in the 1940s and then closed again in the 1950s. In 1976, the roof collapsed and the building was torn down.

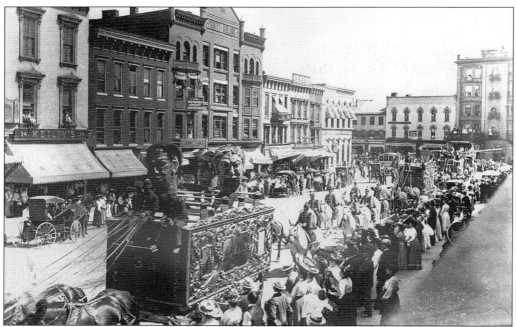

Great excitement was generated when the circus came to town. Circus parades always drew a large crowd of children and adults. Shown here c. 1905 on Seneca Street is a circus parade, probably on its way to the circus grounds on the north end of the city. Circuses made regular appearances in small towns up to the 1950s.

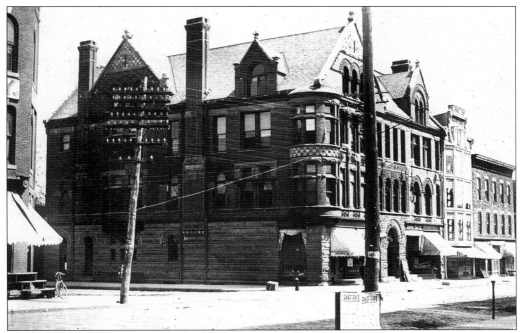

This YMCA building was completed in 1894 on the site of "the old Scotch church" (see page 82). The Y raised $40,000 for its construction. This building burned, for 22 hours, in February 1902. The exterior remained structurally sound and the building was rebuilt, the most noticeable change being the replacement of the gabled roof with a flat story. The Y reopened on November 7, 1904.

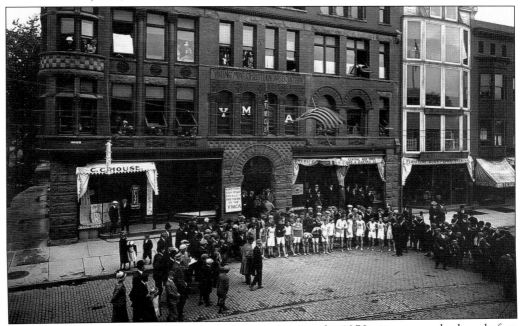

Although running may seem like a sport that was born in the 1970s, it was popular long before that. This marathon in 1912 was set to go in front of the YMCA on Castle Street.

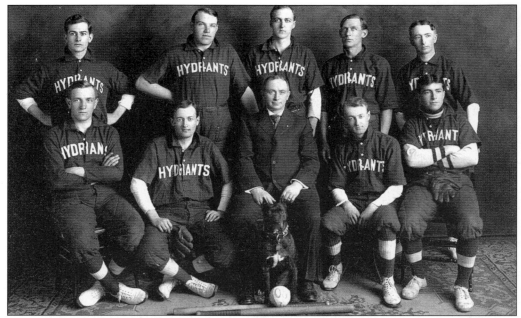

Indoor baseball was the rage by 1896. Here is the Hydrant Hose Fire Company's 1908 team, from left to right, as follows: (front row) unidentified, Greg Rogers, Reuben Gulvin (manager), unidentified, and John Cooley; (back row) Thomas Gibson, Harry Little, Charles Folger, John Balfour, and unidentified. The Hydrant's claim to fame was hosting Christy Mathewson and a team of New York major leaguers at the Armory on January 6, 1910. The local team won 13-2.

This photograph shows an adult city league basketball team in 1910. The players appear a little too well muscled for high school athletes. Holding the ball is Earl Lautenslager, and standing behind him is Henry Merrill Roenke Sr. (Courtesy of Mr. and Mrs. Robert Lautenslager.)

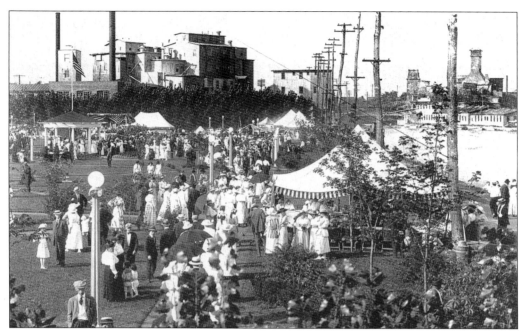

This view of Lakeside Park in the 1920s shows a mixed use of manufacturing and leisure activities on the waterfront. Fay & Bowen, Patent Cereals, and Nester Malt House are visible in the background. Lakeside was an active community park from 1916 through the 1940s. The site became a parking lot in the 1950s.

The inscription on the reverse of this photograph is "Our friends down by the lake around 1910—1st left Louis Richards, 2nd left Tom Wood (Auctioneer)." Nothing more is known about this "stag" gathering at an unknown lakeside location. Some of the men have actually relaxed enough to remove their coats and hats.

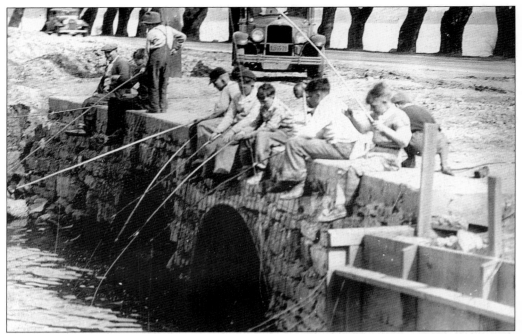

Fishing has always been a favorite pastime for Genevans. These fellows are fishing in the canal in the 1930s. People had fished here since the mid-1800s. By the 1900s, it was mostly filled with carp. Art Kenney fished in the canal, using raw potato dipped in anise and oil for bait. Route 5 & 20 (Lake Road) is shown between the canal and the lake.

Francis and Annie Herendeen's only child was Frances or "Fanny" (second from left). They documented her childhood in great detail. Hammond Tuttle, a professional photographer, came to the house on Lochland Road to take photographs of her birthday parties. Guests at her fourth birthday in 1911, from left to right, are William Packard III, Penelope Hedrick, John Packard (on horse), Betty Packard, and Warren Hunting Smith.

Some people really knew how to party. These two *c.* 1900 photographs appear on the same page of Eloise Wood's scrapbook without explanation. Can you guess what is going on in these photographs? Eloise Wood, the little girl by the rocking horse, grew up to be an artist and professor at Hobart & William Smith Colleges.

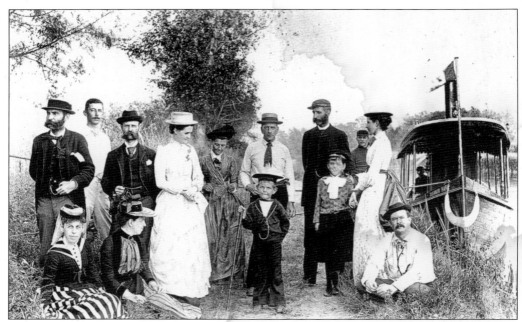

This *c.* 1889 image captures a boating party and a yacht owned by a Antoine deB. Lovett (the tallest man to the right of center) along the Seneca-Cayuga Canal. Among the Lovett family members and friends is nurseryman Theodore Smith (standing, second from the left). The scene offers a wonderful portrait of period fashion in the great outdoors.

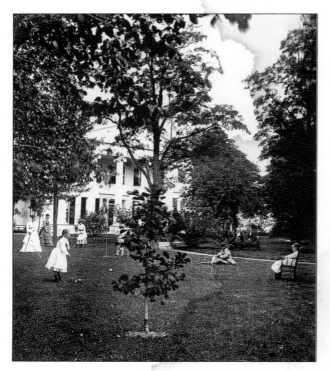

Lawn games were popular in the late 19th century and first half of the 20th century. Here, the Swans are playing croquet on the lawn at Rose Hill, with the mansion in the background. William K. Strong built the mansion in 1839. The Geneva Historical Society now owns this National Historic Landmark.